The World Moves, We Follow

CELEBRATING AFRICAN ART

Frank H. McClung Museum
The University of Tennessee

By William J. Dewey

Contributions by
dele jegede and Rosalind I. J. Hackett

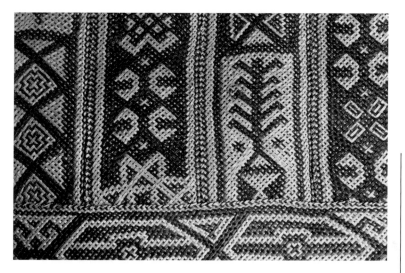

Plate 1. Mat
Swahili peoples, Tanzania, late 19th - early 20th century
Palm fiber
Detail, overall H x W: 230 x 105 x cm (90 1/2 x 41 3/8 in.)
The Field Museum, Chicago
88447
Photograph by Diane Alexander White
Negative #A114184 2c

Front Cover: (clockwise from left)
PLATE 46. Mask (Chikunza) (p. 45)
Chokwe peoples, Angola/ Zambia,
19th or early 20th century
Wood, fibers, pigment
H x W x D: 136 x 38 x 29 cm
(53 1/2 x 15 x 11 1/2 in.)
Private collection
Photograph by Lindsay Kromer

PLATE 16. Chair (Akonkromfi) (p. 24)
Asante Akan People, Ghana,
probably mid/late 19th century
Wood, leather, brass
H x W x D: 96.5 x 61 x 53.3 cm
(38 x 24 x 21 in.)
The Art Institute of Chicago,
Restricted gift of Jamee J. and Marshall Field
2000.347
Photograph by Robert Hashimoto
Photograph © The Art Institute of Chicago

PLATE 61. Bush Spirit Figures (Asie Usu) (p. 53)
Baule, Côte d'Ivoire, 20th century
Wood, kaolin, animal hair
Male H: 48.5 cm (19 1/8 in.),
Female H: 50 cm (19 11/16 in.)
UCLA Fowler Museum of Cultural History
The Jerome L. Joss Collection
Male FMCH X86.1739, Female FMCH X86.1740
Photo by Dennis J. Nervig
Photograph © UCLA Fowler Museum
of Cultural History

**PLATE 62. Other World Figures
(blolo bian, blolo bla)** (p. 53)
Baule, Côte d'Ivoire, male c. 1960, female c. 1965
Wood, enamel paint
Male H: 33.6 cm (13 1/4 in.),
Female H: 39.5 cm (15 9/16 in.)
UCLA Fowler Museum of Cultural History
Anonymous Gift
Male FMCH X94.18.2, Female FMCH X94.17.5
Photo by Dennis J. Nervig
Photograph © UCLA Fowler Museum
of Cultural History

PLATE 38. Headrest, (Musawa or musua) (p. 39)
Yaka People, Democratic Republic of Congo
(formerly Zaire)
mid 19th century/early 20th century
Wood H x W x D: 16.7 x 17.4 x 9.8 cm
(6 9/16 x 6 7/8 x 3 7/8 in.)
The Art Institute of Chicago
Gift of George F. Harding
1928.175
Photograph by Robert Hashimoto
Photograph © The Art Institute of Chicago

Inside Front Cover:
Plate 47. Maiden Spirit Mask (p. 45)
(Agbogho Mmuo)
Igbo peoples, Nigeria, early/mid 20th century
Wood, pigment, fabric
H: 40.7 cm (16 in.)
The Art Institute of Chicago
African and Amerindian Art Purchase Fund
1972.802
Photograph by Robert Hashimoto
Photograph © The Art Institute of Chicago

Inside Back Cover:
Plate 45. Mask (Kholuka) (p.44)
Yaka people, Democratic Republic
of the Congo (formerly Zaire),
20th century
Wood, polychrome, fiber
H: 71 cm (28 in.)
UCLA Fowler Museum of Cultural History
The Jerome L. Joss Collection
FMCH X83.978
Photo by Dennis J. Nervig
Photograph © UCLA Fowler Museum
of Cultural History

Back Cover:
PLATE 15. Wrapper (Kente) (p. 23)
Asante peoples, Ghana, 20th century
Cotton, silk
H x W: 132 x 88.3 cm (51 15/16 x 34 3/4 in.)
National Museum of African Art,
National Museum of Natural History,
Smithsonian Institution
Purchased with funds provided by the
Smithsonian Collections Acquisition Program,
1983-85
EJ10597
Photograph by Franko Khoury
Photograph © National Museum of African Art,
Smithsonian Institution

This catalogue is published in conjunction with the exhibition
The World Moves, We Follow: Celebrating African Art.

Frank H. McClung Museum
The University of Tennessee
January 11, 2003 - May 18, 2003

Curator: William J. Dewey

PAN E01-1006-003-03
Kimberly Johnson, Designer
Kathryn Aycock, Production Editor
Penny Brooks, Production Coordinator
UT Creative Services job # 6336

Published by
Frank H. McClung Museum
The University of Tennessee
1327 Circle Park Drive
Knoxville, Tennessee 37996-3200
Telephone: (865) 974-2144

Occasional Paper Number 15

© Copyright 2003 by the Frank H. McClung
Museum, The University of Tennessee.
All rights reserved.

Library of Congress Cataloging-in-Publication Data

Dewey, William Joseph.
 The world moves, we follow : celebrating African art / by William J.
Dewey ; with contributions by dele jegede and Rosalind I. J. Hackett.
 p. cm.
Catalog of an exhibition to be held at the Frank H. McClung Museum,
Knoxville, Tenn., in the spring of 2003.
Includes bibliographical references.
 ISBN 1-880174-05-7 (pbk. : alk. paper)
 1. Art, African—Exhibitions. I. Jegede, Dele, 1945– II. Hackett,
Rosalind I. J. III. Frank H. McClung Museum (Knoxville, Tenn.) IV. Title.
N7380.5.D48 2003
709'.6'07476885—dc21

2002153170

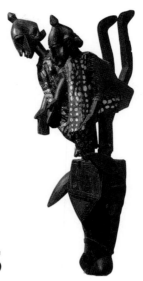

Table of Contents

THIS BOOK IS DEDICATED TO
*my family, both nuclear and extended,
in the United States and Africa.*

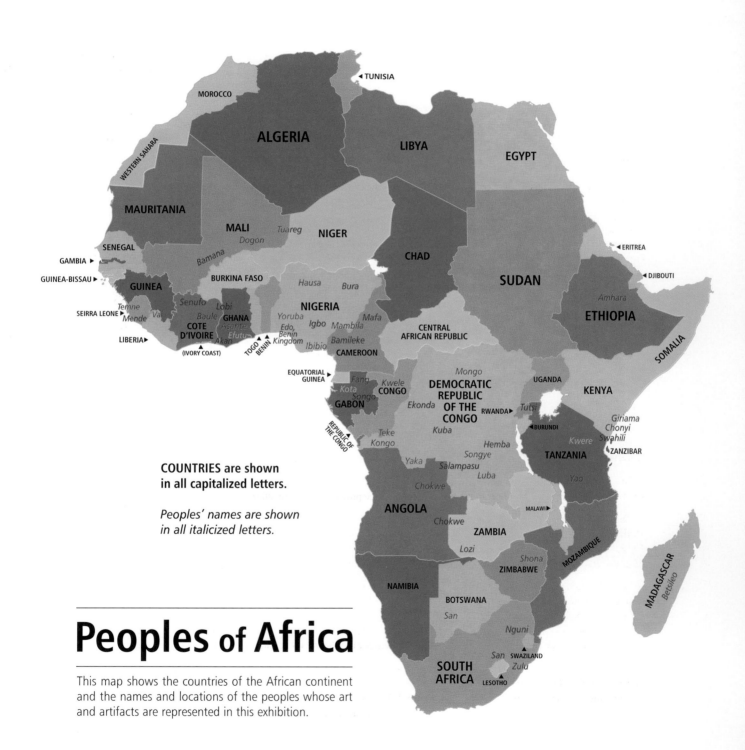

COUNTRIES are shown
in all capitalized letters.

*Peoples' names are shown
in all italicized letters.*

Peoples of Africa

This map shows the countries of the African continent
and the names and locations of the peoples whose art
and artifacts are represented in this exhibition.

Map labels — countries: TUNISIA, MOROCCO, ALGERIA, LIBYA, EGYPT, WESTERN SAHARA, MAURITANIA, MALI, NIGER, CHAD, SUDAN, ERITREA, DJIBOUTI, SENEGAL, GAMBIA, GUINEA-BISSAU, GUINEA, BURKINA FASO, NIGERIA, ETHIOPIA, SEIRRA LEONE, GHANA, COTE D'IVOIRE (IVORY COAST), LIBERIA, TOGO, BENIN, CAMEROON, CENTRAL AFRICAN REPUBLIC, SOMALIA, EQUATORIAL GUINEA, CONGO, DEMOCRATIC REPUBLIC OF THE CONGO, UGANDA, KENYA, GABON, REPUBLIC OF THE CONGO, RWANDA, BURUNDI, ZANZIBAR, TANZANIA, ANGOLA, MALAWI, ZAMBIA, MOZAMBIQUE, ZIMBABWE, MADAGASCAR, NAMIBIA, BOTSWANA, SWAZILAND, SOUTH AFRICA, LESOTHO

Peoples: *Tuareg, Dogon, Bamana, Hausa, Bura, Senufo, Lobi, Baule, Ashcite, Yoruba, Edo, Benin Kingdom, Igbo, Mafa, Mambila, Bamileke, Ibibio, Temne, Mende, Val, Efutu, Akan, Amhara, Mongo, Fang, Kwele, Kota, Songo, Ekonda, Tutsi, Giriama, Chonyi, Swahili, Kwere, Teke, Kongo, Kuba, Hemba, Songye, Luba, Yao, Yaka, Salampasu, Chokwe, Lozi, Shona, Betsileo, San, Nguni, San, Zulu*

Acknowledgements

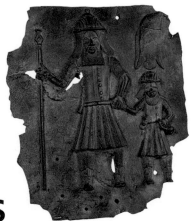

The many institutions and individuals that lent objects for the exhibition deserve special thanks. Those individuals who facilitated looking at collections and arranging loans include: from the Field Museum of Chicago—*Chapurukha Kusimba*, curator of African archaeology and ethnology, and *Dorren Martin-Ross*, registrar in the Department of Anthropology; from the Indianapolis Museum of Art—*Ted Celenko*, curator of African, South Pacific, and Pre-Columbian Art; from the Art Institute of Chicago—*Kathleen Bickford Berzok*, associate curator of the African Art Department, and *Richard Townsend*, curator of African and Amerindian Art Department; from the Smithsonian National Museum of African Art—*Bryna Freyer*, assistant curator, *Julie Link Haifley*, registrar, and *Janet Stanley*, librarian; from the Smithsonian National Museum of Natural History—*Mary Jo Arnoldi*, head of the Division of Ethnology and curator of African Collections, *Debra Hull-Walski*, collections manager, Department of Anthropology, and *Donald Hurlbert*, photographer.

For helping out with last minute requests to fill in gaps in our plans and heroically arranging for loans and photography by staff members of the Fowler Museum of Cultural History at UCLA, special thanks go to *Polly Roberts*, associate director and chief curator; *Sarah Kennington*, registrar; and *Don Cole*, photographer. At the New Orleans Museum of Art, *William Fagaly*, the Françoise Billion Richardson Curator of African Art, deserves special commendation for helping out in a pinch and facilitating loans and photography. Special thanks also to *Bill, Charles*, and *Kent Davis* and to *Michael* and *Cathy Conner* for their hospitality when I was visiting New Orleans. Thanks to *Kate Ezra* for Chicago hospitality. Thanks to *Craig Subler, Kathleen Bickford Berzok*, and *Charles* and *Kent Davis* for lending objects for the exhibition, and to *Al Roberts, Manuel Jordan, Vicki Rovine*, and *Diane Pelrine* for assistance of various sorts. *Rosalind Hackett* of the Department of Religious Studies at the University of Tennessee in Knoxville and *dele jegede*, chairman of the Art Department at Indiana State University in Terre Haute, Indiana, helped immeasurably with their contributions of chapters to the catalogue.

Special thanks to the support of the University of Tennessee especially *Loren Crabtree*, vice president and provost; *Phil Scheurer*, vice president for operations; and *Tim Rogers*, vice provost for student affairs.

Thanks go to the Frank H. McClung Museum—*Jeff Chapman*, director, for inviting me to curate this exhibition and to all the museum staff for their help, especially *Lindsay Kromer*, photographer; *Steve Long*, exhibits coordinator; *Charles Hurst*, exhibits preparator; *Robert Pennington*, registrar; *Kristina Arnold*, registrarial assistant; *Deborah Woodiel*, museum educator; and *Elaine Evans*, curator.

The exhibition was made possible by generous sponsorships from First Tennessee Bank, the William B. Stokely, Jr. Foundation, Pilot Corporation, the East Tennessee Foundation, the Aletha and Clayton Brodine Museum Fund, the UT Office of the Provost, the *Knoxville News-Sentinel*, WBIR-TV, and by a grant from Tennessee Humanities, an independent affiliate of the National Endowment for the Humanities (the findings and conclusions of this publication do not necessarily represent the views of Humanities Tennessee or of the National Endowment for the Humanities).

Lastly, I want to thank those involved in the production and printing of this catalogue: UT Creative Services—*Kathy Aycock* for editing, *Kimberly Johnson* for the superb design, *Penny Brooks* for production assistance and for coordinating the printing with B & B Printers of Bristol, Tennessee. I appreciate the efforts of the staff of UT Press, led by *Jennifer Siler*, for efforts early on in the catalogue's development and finally for assistance in promotion and distribution.

William Dewey
Curator

Foreword

With the McClung Museum's mission to advance understanding and appreciation of the earth and its peoples, I had for some time wished to do an exhibition on Africa. As soon as I met Bill Dewey in October 2000, I knew we had our person that could make this happen. I appreciate Bill's willingness and enthusiasm to organize and curate *The World Moves, We Follow: Celebrating African Art*. The exhibition was an ambitious and expensive undertaking for a museum our size. Its success is a testimony to the talent and commitment of the museum staff and to those who believed in and supported the project.

This catalogue is an integral part of the exhibition in that it affords the visitor an opportunity to explore in greater depth the richness and diversity of African cultures. Bill Dewey and contributors Rosalind Hackett and dele jegede convey both the change and continuity that are expressed in African art and do much to dispel popular stereotypes of African culture. Once the exhibition objects have been returned to their respective lenders, the catalogue will continue to celebrate African art.

Jefferson Chapman
Director
Frank H. McClung Museum

"Ayé nyí, à ntò ó"
The World Moves, We Follow
Celebrating African Art

The Yoruba acknowledge the inevitability of change and the significance of human actions in influencing the course of events and the direction that change takes. It is the ability to revitalize—to adopt, adapt, and synthesize—that is responsible for the vitality of their arts. "Ayé nyí, à ntò ó" (literally, "the world moves, or turns, we follow") underlines a philosophical attitude shared by many African cultures, which privileges creative individuals as pace setters in a world where change is embraced as a necessary tonic for rejuvenation and creativity. That is why the Yoruba concept of "lògba lògba" (meaning, "going with the times") as well as "Ayé nyí, à ntò ó" ("the world moves, we follow") resonates among many African cultures where creativity reveals flashes of the future without subverting the past.[1]

This point about the inevitability of change must be made for the general public (reinforced through media stereotypes) who still too often sees African art as primarily being composed of exotic masks and figure carvings coming from a nebulous time period, the so-called "ethnographic present." Seeking to introduce African art to a new audience (eastern Tennessee has never had a major general exhibition of African art), I designed this exhibition as a general broad survey of African art forms. African art survey exhibitions have been presented in a number of world venues. Many surveys have focused on particular collectors and their tastes for figures and masks, or they have been drawn from permanent collections of museums and reflect the museum's own collection history and the story they currently tell about Africa. Since locally there are neither museum collections nor many collectors of African art, the challenge has been to come up with a way to celebrate the artistic richness of the African heritage as inclusively as possible. It is imperative to incorporate some of the newest research on previously neglected artforms and geographic areas and include these arts under the umbrella of what represents African art. The neglected geographic areas of southern and eastern Africa, and Ethiopia, and the largely ignored artforms such as weapons, furniture, currency tokens, textiles, and contemporary art are therefore incorporated into this exhibition. I have chosen to completely integrate the widest possible range of artforms and thus confirm their incorporation into the canon of African art.

To do this successfully it was critical to select the very best examples of many categories of objects. The numerous institutions and individuals that lent objects to the exhibition have generously helped to try to accomplish this goal. The exhibition is organized into the following themes: Leadership and Status, Death and the Ancestors, Utility and the Art of Living, Transitions and Dealing with Adversity, and Connecting with the World. Art has multiple uses, and, at times, the arbitrary assignments to categories, of course, distorts its true nature. Each object is the product of a particular culture and a particular time, and so in an effort to avoid oversimplification and generalizations, I have chosen to devote more attention to the explanation of individual objects. Objects that are included cover a variety of forms (masks, figures, textiles, paintings, weapons, furniture); time periods (ranging from a bronze head and plaque from the ancient kingdom of Benin up to contemporary times with factory-printed cloth and art about the Truth Commission hearings in South Africa); and geographic areas (ranging from Madagascar to eastern and southern Africa, through central and western Africa to northern and northeastern Africa). Rosalind Hackett (University of Tennessee professor of African religion) has contributed a chapter on art and religion and dele jegede (professor of African art history at Indiana State University) contributed one on relationships between "traditional" and "contemporary" African art forms. Both of their perspectives help expand our understanding of African art.

My major professor, the late Roy Sieber, loved to tell his classes the following story. He pointed out that when people dismiss art they do not like with the commonly-heard expression "I know what I like," actually they are saying "I like what I know." Familiarity encourages ease of understanding but also knowledge increases familiarity. The explanation of the social, political, and historic setting of African Art will hopefully enhance your familiarity with it. A favorite anecdote about the Nobel prize-winning author Wole Soyinka concerns his response when badgered as to why he did not adhere more to the philosophies of Negritude[2]. He replied that a tiger does not have to proclaim it's tigretude, it just pounces! I do not claim to be either a tiger or on par with Soyinka but I do believe that with some understanding of the background and context of African art, its intellectual and aesthetic beauty will not need to proclaim itself, it will just pounce upon you. ∎

[1] Dele jegede kindly offered help with these thoughts on the Yoruba title. I also sought help for Yoruba translations from my University of Tennessee colleague Deji Badiru. The merit of translations is their accomplishment. Any misrepresentations or shortcomings concerning the nuances of language are mine.

[2] A philosophical and literary black consciousness movement of the 1950s associated with the authors and poets Léopold Sedar Senghor and Aime Césaire

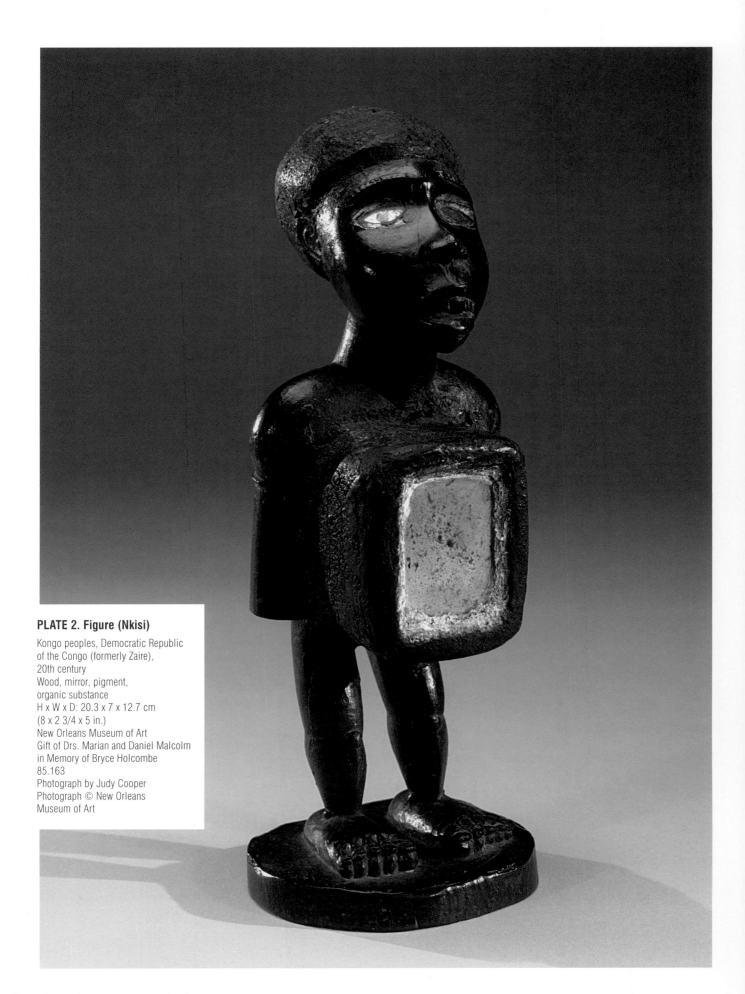

PLATE 2. Figure (Nkisi)

Kongo peoples, Democratic Republic
of the Congo (formerly Zaire),
20th century
Wood, mirror, pigment,
organic substance
H x W x D: 20.3 x 7 x 12.7 cm
(8 x 2 3/4 x 5 in.)
New Orleans Museum of Art
Gift of Drs. Marian and Daniel Malcolm
in Memory of Bryce Holcombe
85.163
Photograph by Judy Cooper
Photograph © New Orleans
Museum of Art

This is African Art?
Now You Confuse Me

dele jegede—Indiana State University, Terre Haute

PLATE 3. Male figure (Bateba)
Lobi people, Burkina Faso
20th century
Wood and iron
H: 69.4 cm (27 3/4 in.)
Indianapolis Museum of Art
Gift of Mr. and Mrs. Harrison Eiteljorg
IMA1989.181
Photograph © Indianapolis
Museum of Art

To the lay public, African art is synonymous with wood sculpture. For some, it invokes this eerie feeling that transports the mind to a liminal province and floods the imagination with images of fantastic, even phantasmagoric, masks that are adorned with unfamiliar appurtenances. Didn't somebody say that the masks are used in connection with their "tribal" ceremonies? For others, African art is exemplified by sculptures or "fetishes" once immersed in an accumulation of indeterminate liquid substances. Sometimes the sculptures are adorned with additional "exotic" items, or festooned in colorful materials such as beads, shells, appliqué, raffia, and feathers. African art, for this group, is the art that exists in Africa.

Tautological or even simplistic as this may sound to the trained ear, it probably captures the welter of experiences, and the cascade of emotions—excitement, shock, fascination, love, and bewilderment—that many feel upon first making contact with African art. Our appreciation of African art grows only when we have an understanding of the context within which the art is produced. While we may be fascinated by the unusualness of the figures, such appreciation remains superficial in the absence of a basic understanding of the culture(s) that sustain their production and use. This exhibition must therefore be seen within an educational context. It attempts to build bridges through which cultures can be accessed; through which art becomes the enabling agent that informs, confronts, challenges, and catalyzes change in the viewer.

The diversity of what we call African art is indeed bewildering. Emphatically, it must be said that African art does not consist only of masks and sculptures in the round. It is not "tribal," and neither is it composed of "fetishes" that recall "exotic" practices. African art is total art. It is music, dance, theater, poetry, performance, and visual art rolled into one. Although we are content to view objects displayed in museum cases, it must be understood that in several instances, the objects were not made for the mantelpiece or the coffee table. They were not made to be hung on the wall for visitors to gawk at or to admire. Where they are meant to be seen, such as during public festivals when masquerades are on parade and are active in performance, audience participation may become an essential aspect. But instances also abound where the objects are kept away from the uninitiated gaze and it is taboo for certain people to lay their eyes on them. At most other times when the objects are not in use, they are kept in shrines—personal, familial, or community—where they are supplicated and offered libation. Regardless of how well displayed these objects are, and in spite of every effort that a curator may make in presenting African art objects, we must bear in mind that every piece is but an abbreviated part of an original whole. Without the panoply of ceremonies or the aura of the environment in which they would normally function, most of these objects have lost much of the power to titillate maximum sensory enjoyment.

An essential aspect of these pieces pertains to their spiritual connection. Before they metamorphosed into art objects in our museums, many artworks originated in cultural contexts that placed primacy on their spiritual efficacy. It can be said that an object is considered "beautiful" from an African perspective in the extent that it is successful in achieving its spiritual purpose. A *bateba* carving (see Plate 3) made by the Lobi of Burkina Faso is highly valued because it is not representative of an idea; it is the idea personified. Once consecrated, the *bateba* becomes the mediator between the living and the spirit world. It casts a protective armor around its clients, shielding them from potential harm from witches, sorcerers, and those otherworldly essences who might be inclined to wreak havoc on the innocent, intimidate the defenseless, and make life miserable for the unprotected. In the Democratic Republic of the Congo, an *nkisi* carving (see Plate 2) serves as the spiritual firewall—a dependable force—that, once activated by an *nganga* who is a versatile spiritualist, launches a series of attacks on evil perpetrators, social deviants, adulterers, and thieves who deny society the pleasure of enjoying the fruits of its labor. For this purpose, an *nkisi* is often armed to the teeth, literally. Its

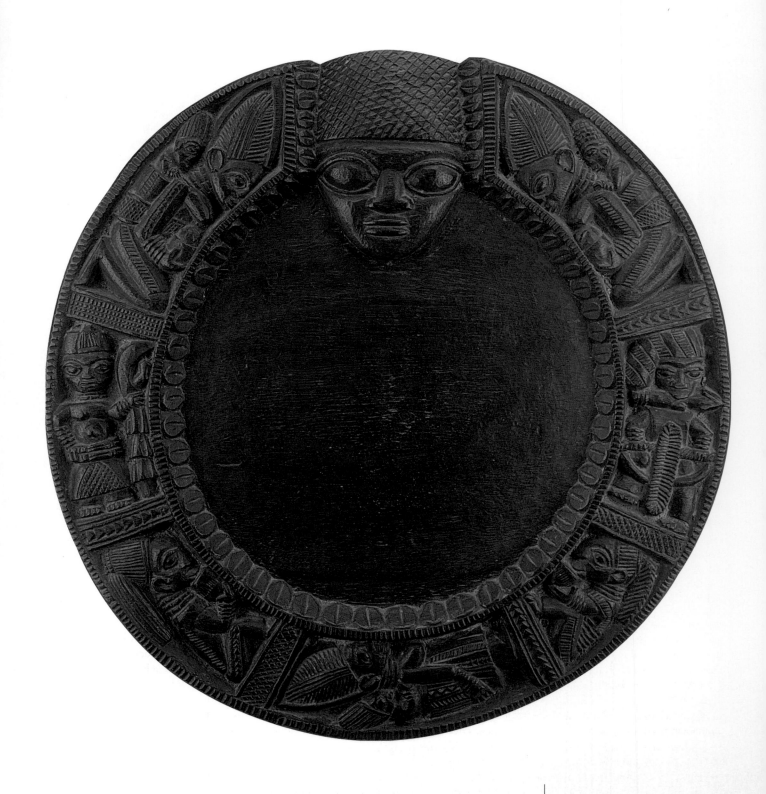

**PLATE 4. Diviner's Board
(*Opon Ifa*)**

Areogun of Osi-Ilorin c. 1880-1954,
Yoruba, Nigeria, early/mid 20th century
Wood
H x Dia.: 5 x 45 cm (2 x 17 3/4 in.)
The Art Institute of Chicago
Laura T. Magnuson Fund
1999.289
Photograph by Robert Hashimoto
Photograph © The Art Institute of Chicago

PLATE 5. Animal

1972 Jimoh Buraimoh (1943 -)
Yoruba peoples, Nigeria
Wood, paint, glass beads, thread,
adhesive, nails
Dimensions H x W x D: 61 x 100 x 2 cm
(24 x 39 3/8 x 3/4 in.)
The Field Museum, Chicago
222112
Photograph by Diane Alexander White
Negative #A114184 9c

abdominal cavity contains powerful medicines that spur it to action. Its beauty consists in its hideousness: in the piles of medicines in which it is ensconced, in its uncompromising posture, and in the forest of blades that are driven into its body as a testament to its efficacy.

One last piece that exemplifies the spiritual connection of African art is the *opon* Ifa (Ifa divination tray) carving (see Plate 4) of the Yoruba of Nigeria. This tray is used by a priest, or *babalawo*, in assisting a client to find spiritual solution to his or her problems. The tray functions as a screen for picking up, recording, and translating a client's aura. Ifa operates at numerous levels: philosophical, symbolic, diagnostic, prescriptive, curative/preventive. The connection between the secular and the spiritual domains is Eshu, the fierce, assertive, and mesmerizing messenger god, whose face is customarily inscribed on the rim of divination trays. If you are deceptive, Eshu will beat you to it and multiply your misery tenfold. But remain loyal and faithful, you will reap bountiful favors from him. Eshu is the liaison that ensures that all sacrifices prescribed by the *babalawo* are accepted by the gods. He is the commander of the crossroads, the one who delights in having his bath while punishing the defiant, using their blood for ablution.

This brief introduction is probably sufficient to convey the point that African art is substantially different from what you know as art in your own community in, say, Knoxville, Tennessee, Boise, Idaho, or Terre Haute, Indiana. However, this is but one side of the coin. The second side, which constitutes a continuum, is generally referred to as contemporary art. You may be inclined to ask what the difference between the two is. You may even wonder whether there is any difference between contemporary African art and contemporary art elsewhere. The short answer to these enquiries is that there is no difference, *conceptually*, between contemporary African art and contemporary art in the Western world. Contemporary art everywhere, for that matter, is energized by the concept of immediacy. The art explores the richness of media, probes a range of approaches, and fiercely asserts the creative independence of the individual artist. It is no less so in Africa. The distinctive difference comes in the ways that style and content or subject matter inflect the finished work. And that, in itself, cannot be divorced from the society and the culture in which the art is produced.

The break from the tradition of creating art that is often tied to life cycles marks the beginning of contemporary art in Africa. The dichotomy between these two strands of art —Traditional and Contemporary—can be traced to the introduction of Western education in Africa. That, of course, is as simplified as we can make it. For, in actuality, the continent of Africa has always been in a flux arising from the myriad of influences that it has been exposed to. Ali Mazrui calls this the triple heritage (1986). Western culture and Islamic mores fuse with traditional African systems of thought to produce a vibrant, pulsating kaleidoscope. As two major world religions—Islam and Christianity—made inroads into the heart of Africa, they fostered changes that have had tremendous reverberations in all spheres of life: social, educational, political, and cultural. The mode of artistic production in the arts mirrored the changes that occurred in the social fabric. For example, the apprenticeship method through which artists honed their skills gave way with the introduction of formal education. Christianity, as introduced by European missionaries, emphasized the secularity of the arts, in contradistinction to traditional art, which is intertwined with traditional religious practices. In Africa, the advent of Christianity also witnessed a series of orchestrated attacks on the arts in the belief that they sustained paganism.

With conversion to Christianity and Islam, patronage of traditional art grew weaker. Correspondingly, interest in Western art began to grow. The third decade of the twentieth century witnessed the formalization of Western art at the college level in sub-Saharan Africa. In Ghana, Uganda, the Democratic Republic of the Congo, Sudan, Nigeria, and Ethiopia, art colleges sprang up with curricula that were modeled after those of elite European art schools. Initial reaction to the new art was mixed. Curiosity soon gave way to skepticism, arising from the notion that a degree in the visual arts was "softer" than, say, a degree in law, medicine, and engineering. This did little to dampen the enthusiasm of art students, many of whom soon traveled to various European cities where they continued their study and, in some cases, stayed and practiced.

Today, there are hundreds of departments of art in African countries, with homegrown curricula. Concomitantly, contemporary African artists have emerged with distinctive identities and with themes and subject matters that plumb the depth of ancient myths

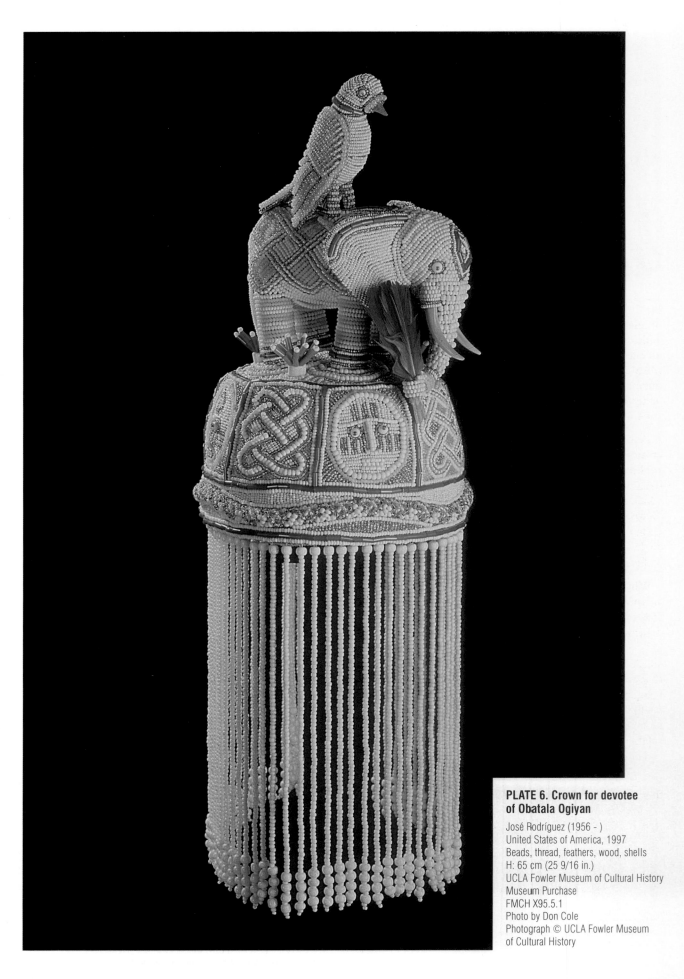

PLATE 6. Crown for devotee of Obatala Ogiyan

José Rodríguez (1956 -)
United States of America, 1997
Beads, thread, feathers, wood, shells
H: 65 cm (25 9/16 in.)
UCLA Fowler Museum of Cultural History
Museum Purchase
FMCH X95.5.1
Photo by Don Cole
Photograph © UCLA Fowler Museum
of Cultural History

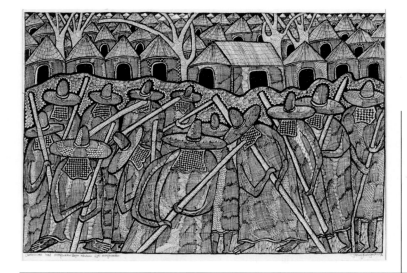

**PLATE 7. Ceremonial Hat Masqueraders
(Lagos-Renown Eyo Masqueraders)**
1996 Twins Seven Seven (1944 -), (Nigeria),
Pen and ink on white paper
H x W: 62.2 x 91.4 cm (24 1/2 x 36 in.) inches
Indianapolis Museum of Art
Delavan Smith Fund
IMA1997.99
Photograph © Indianapolis Museum of Art

or celebrate indigenous modernities. In the 1960s, there arose a second flank, which de-intellectualized the creative process. Known as the "experimental" school, the objective of the protagonists of this school was to cut through all the fetish of the typical Western art curriculum and produce artists with minimum fuss and at little cost. The workshop that best exemplifies this approach was the Mbari Mbayo, or as it is more popularly known, Osogbo School, named after a city in southwestern Nigeria. In 1962, Ulli Beier and Susanne Wenger began the first in a series of yearly art workshops that were meant for the underprivileged, the indigent, and the undereducated. Two of the prominent artists to emerge from the third experimental workshop that took place in Osogbo in August 1964 were Jimoh Buraimoh and Twins Seven Seven[1] (see Plates 5 and 7).

Before he opted for the workshop, Jimoh Buraimoh was an electrician on the theater group of Duro Ladipo, a key actor in the creative effervescence that erupted in Osogbo in the 1960s. Like many of those who came to prominence through the experimental workshops in Osogbo, Jimoh Buraimoh never envisioned himself as a visual artist. Through experimentation, he evolved a style that has now become his professional trademark. His beaded art is unique because it appropriates the Yoruba ideal of dignity and vividness, which are manifested in Yoruba beaded crowns (see Plates 9 and 6) that are worn exclusively by Yoruba kings, who are called Oba. Taiwo Olaniyi, who is known more popularly as Twins Seven Seven, is unquestionably the artist that epitomizes the spirit of Osogbo. Because he is the only surviving son out of seven pairs of twins, he symbolizes the spirit of *abiku*—mysterious children who are born to die; children who torture their mothers by dying at will, and willing themselves to be born by the same woman in an endless cycle.

Why is this important? The idea that he is an unusual personage defines his work. His self-assuredness and flamboyance, his versatility in dance, music, and the visual arts, his own personality that is gregarious and compelling—all of these are an extension of his art. His work reveals a compulsive aversion to empty spaces. Be they prints, relief panels, paintings, or black and white drawings, Seven Seven's work is permeated by a desire to fill every available space. *Eyo Masquerades* (see Plate 7) mythologizes the most colorful festival in the city of Lagos. As with most of Seven Seven's work, it is an ideographic piece that makes tangential allusion to Eyo, the masqueraders that enchant the people of Lagos Island with their contemporary hauteur. The key characteristics that Seven Seven highlights here are the *akete* (hats), *opambata* (long bats), and *ago*, the voluminous white gowns in which Eyo masqueraders are always clad. The masqueraders exist in a different world, as anyone who is familiar with the city of Lagos will readily attest. Rather than frame them within a stifling cosmopolitan ambience, the masqueraders are located in a world of thatched roofs and rounded huts, all squashed up within an imaginary jungle. This work draws on the creative strength of the artist and capitalizes on a penchant for creating his own world, populating it with his own people who exist according to his creative whims and fancies.

In a different but real world, a world that, for a terribly long period, was polarized by gross abuse, intolerance, and racial bigotry, there lived another artist who, through his art, confronted the mindless acrimony that plagued his world. In South Africa, Ezrom Legae's heroic attempt at purging himself of the bitterness that apartheid wrought on his soul gave his art an enchanting power. Rather than vent his spleen on the perpetrators of apartheid, Legae imbued his work with such empathy and verve that they seem to palpitate with energy. His series of small, pen and ink drawings complement his bronze sculptures of decapitated or contorted animals in a way that seems to be celebratory and cautionary: the end of apartheid deserved to be commemorated, but nothing should be done to mitigate the episode, to rationalize or resuscitate it in any form. Legae's art melds sensitivity with courage. Employing tortured animals and burned flesh as metaphor for the stench that apartheid produced, Legae used his work to confront

[1] Other artists who emerged from the Osogbo workshop included Jacob Afolabi, Rufus Ogundele, Muraina Oyelami, and Adebisi Fabunmi. For an authoritative account of the Mbari Mbayo Club of Osogbo, and the series of workshops that elevated the city to cultural prominence, see Ulli Beier, *Contemporary Art in Africa*. New York: Frederick A. Praeger, 1968.

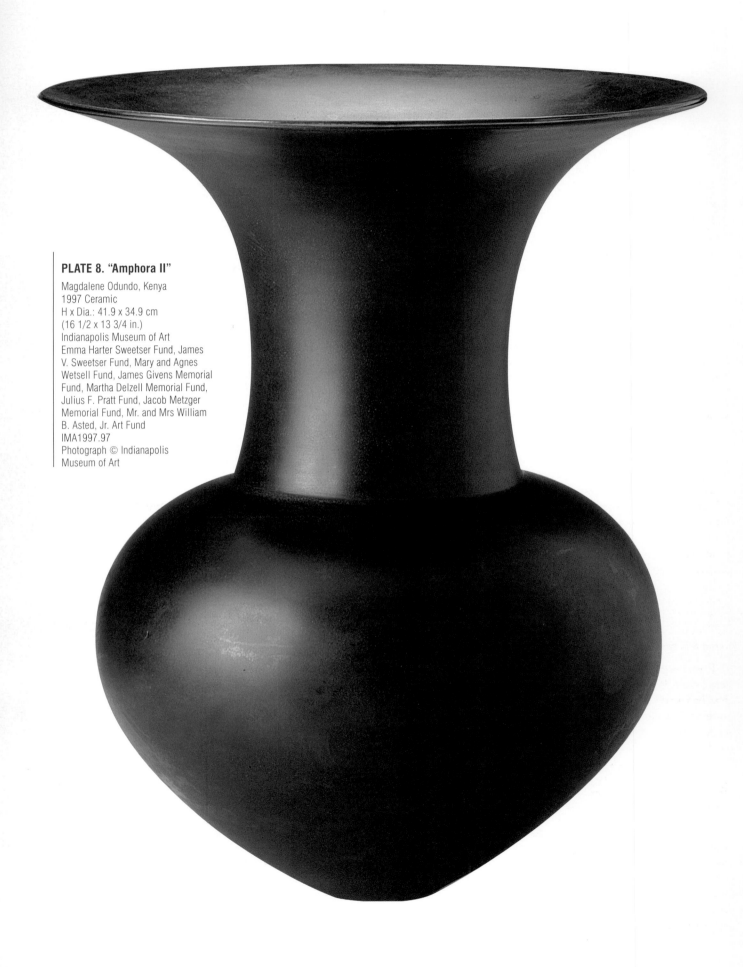

PLATE 8. "Amphora II"

Magdalene Odundo, Kenya
1997 Ceramic
H x Dia.: 41.9 x 34.9 cm
(16 1/2 x 13 3/4 in.)
Indianapolis Museum of Art
Emma Harter Sweetser Fund, James
V. Sweetser Fund, Mary and Agnes
Wetsell Fund, James Givens Memorial
Fund, Martha Delzell Memorial Fund,
Julius F. Pratt Fund, Jacob Metzger
Memorial Fund, Mr. and Mrs William
B. Asted, Jr. Art Fund
IMA1997.97
Photograph © Indianapolis
Museum of Art

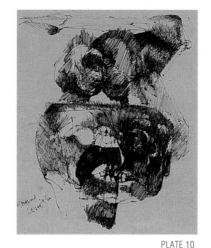

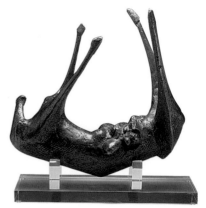

PLATE 9

PLATE 10

PLATE 11

the system. Among the body of work that he created in 1996 are *Assassins* (pen and ink on paper) (see Plate 10) and *The Dying Beast* (cast bronze) (see Plate 11). These pieces amplify the essence of the Truth and Reconciliation Commission that followed the dismantling of apartheid in 1994. Although Legae died in 1999 at the age of 61, the fundamental issues that he addressed himself to continue to animate South African art today.

At the beginning of the twentieth century, African artists in their respective countries came under a barrage of attacks that were initiated primarily by European missionaries who associated African art with traditional African religious systems, which they perceived as heathenish and intolerable. At the end of that same century, a remarkable turn-around had occurred. African artists living in Europe and the United States began to exert their creative influence on Western art. In 1974, the Ethiopian artist, Skunder Boghossian moved to Washington, D.C., and began a creative odyssey that has left a strong impact on generations of contemporary African and African-American artists. In England, there was Uzo Egonu, who moved to that country in 1945 and practiced there as an artist until his death in 1998. Towards the end of that century, it was no longer fashionable to feign ignorance about contemporary African art because of the impact that a new generation of Europe-based African artists continued to make. In their work, these artists promote hybridity and eclecticism. Yinka Shonibare and Chris Ofili, both of them London-based artists of Nigerian parentage, continue to enjoy international acclaim on account of their ability to rupture conservative notions about art in general and African art in particular. Ofili's 1996 painting of *The Holy Virgin Mary*, for example, stirred international furor because of the use of elephant dung and pornographic elements.

It is into this mix that we bring Magdalene Odundo (see Plate 3), the Kenya-born artist who, since 1971, has made London her base. By the time she moved to London, Odundo had had a rich grounding in her native Abaluya culture, in addition to a trip to India and tutelage in a convent school. This exposure to disparate cultural streams would eventually constitute the bedrock of her art as a ceramic artist. Drawing from ancient Maya, Western antiquity, Chinese, and African sources, Odundo's vessels become a celebration of world cultures. In 1974, she traveled to Nigeria and Kenya, where she apprenticed herself to local potters and perfected her skills in hand-building and firing techniques. The pristine elegance that her minimalist vessels radiate testifies to Odundo's ability to judiciously adopt and adapt, to synthesize and impose order on her sources.

It is this ability to respond to changes in concepts and structure that characterizes contemporary African art. Rather than succumb to notions of art that are imposed by others and produce works that fit preconceived formula, African artists continue to express their own individuality, time, and space. In doing so, they contribute to the blurring of boundaries and demolish stereotypical hierarchies. This exhibition highlights linkages and subtleties in African art. Artists are cultural scribes who, in their work, mirror our current stations at the same time that they predict the future. ∎

Connecting Worlds:
Art and Religion in Africa

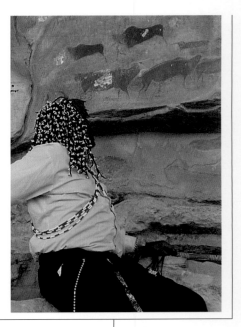

Rosalind I. J. Hackett, The University of Tennessee, Knoxville

PLATE 12.

Present-day Zulu *Sangoma* (healer), Elliot Ndlovu views rock art in the Drakensburg region of South Africa. He lives in the area but is unfamiliar with the symbols of the San who may have intermarried with his ancestors. *Photograph by Rosalind I. J. Hackett*

Several years ago I was asked to write a volume on African art and religion for a new series on Religion and the Arts. I boldly agreed, not because I was an expert on the subject, but because I had encountered many examples of artistic expression when conducting my study of religious pluralism in Calabar, south-eastern Nigeria, in the early 1980s. I had been lucky enough to be there when the paramount ruler, or *obong*, passed away and a new one was installed. I was privileged to witness the elaborate funerary and installation ceremonies in the palace grounds and surrounding streets. Colorful masquerades abounded as the various secret societies, notably *Ekpe*, and cultural and communal associations came to pay homage. I had also seen the carved Mami Wata figurines of local *ndem*, or water spirit, priests and priestesses when taken by a student to visit neighboring Ibibioland. It now remained for me to explore these interconnections more intensely and more comparatively.

For the next few years I set about tracking down literature which discussed how the visual and performing arts in Africa could provide a vehicle for religious ideas and examining the roles played by art objects in ritual contexts. This proved to be a challenge as there were endless examples but little explicit scholarship on the relationship between artistic and religious concepts. Art historians rarely ventured beyond stating that art objects might represent spirit beings or that they had a ritual function. Anthropologists, with a few exceptions, seldom did justice to material culture and art. Scholars of African religion were even more unhelpful, either ignoring the visual dimension completely or considering traditional art as merely instrumental to the inculturation of Christianity.[1] However, thanks to the support of several African colleagues I was encouraged to pursue the spiritual and philosophical underpinnings of African art. They were more attuned to the role of religious beliefs in inspiring the creation and influencing the use of many African artworks.

Over the years I was able to piece together enough examples and sources to constitute a viable text. It was eventually published in 1996 as *Art and Religion in Africa*.[2] What follows in this essay is an overview of what I learned as a scholar of religion, trained in the historical and social scientific study of religion in Britain, in taking on this project, and why I now trumpet the merits of a more multi-dimensional approach to the study of religion in Africa. The earlier studies of African traditional religion in the 1960s and 1970s which emphasized concepts of God and belief systems were timely given the nationalistically oriented politics and theology of the academy at the time (Westerlund 1985). Happily the prospects for today's students and researchers are much enhanced with regard to factoring in material and expressive culture. In addition to an array of fabulous catalogues and exhibitions, there are excellent studies which supply rich iconographic and ethnographic analysis.[3] Web sites, video tapes, and CD Roms are also now available which can give one virtual access to all forms of African artistic expression.[4]

I naturally had to make choices at an early stage about how I would approach the wealth of data on African art and its religious meanings and uses. Going against the grain of the majority of art historical texts which examine art employing the criteria of form, style or region, or those of anthropologists who focus on a particular ethnic group or area, I opted for a more comprehensive viewpoint organized around selected themes. These themes were leaves out of a religion scholar's notebook: creation and creativity, spirit representation and embodiment, leadership and authority, initiation and secret societies, protection from evil, sacred places and death. Such a diversity of topics also impelled me to include a wide variety of media, not just sculpture and masks–so privileged by Western curators and collectors–but also textiles, pottery, and

[1] The late Professor E. Ikenga Metuh, Roman Catholic priest and former head of the Department of Religious Studies at the University of Jos, Nigeria, was an exception as he included a chapter on art in his broader work on religion in Africa (Ikenga Metuh 1985). Thankfully, there are now some younger scholars, such as David O. Ogungbile of Obafemi Awolowo University, who are conducting research on religious iconography and ritual art (Ogungbile n.d.).

[2] Many of the topics and examples discussed here receive more detailed treatment in the book (Hackett 1996).

[3] A couple of my favorites are Patrick McNaughton's work on Mande blacksmiths (McNaughton 1988) and Suzanne Preston Blier's book on *African Vodun* (Blier 1995).

[4] See, for example, the Art and Life in Africa Project at the University of Iowa: http://www.uiowa.edu/~africart/

jewelry which could be just as revealing of cosmogony and cosmology. This also ensured that women's arts would be included.

An initial hurdle to be surmounted was the issue of terminology. Most African languages do not have words for "art" and "religion." That does not mean that they do not have terms for decoration, embellishment, or sacrifice and deities. But certain hermeneutical and conceptual moves are required for comparative analysis. Wherever possible I sought to ground these in local terms and ideas. The type of multi-disciplinary and multivocal scholarship available on the Yoruba of south-western Nigeria, for example, by both African and Africanist scholars, permits this more nuanced inquiry (e.g. Drewal, Pemberton, and Abiodun 1989). It also further challenges the primitivist stereotyping or arrogant neglect of the study of the local, indigenous forms of artistic and religious expression in Africa within the bigger pictures of "world art" and "world religions."

My goal is more radical than supplementary in this short essay. I am positing that a focus on art objects provides a window onto the complexity of African conceptual worlds that studies of beliefs and practices alone cannot provide. This is especially the case with cultures that are more oral in orientation. Likewise, attention to the religious dimensions of artistic expression results in a richer, more multi-layered understanding than that offered by conventional formal analysis. In sum, a focus on the ways in which works of art connect the worlds of humans, nature, and the spirits provides a fresh perspective on African art, challenging us to reconsider the links between form, meaning, experience, function, and context.

By way of tackling some of these "blind spots" I wish to consider some of the key ideas that emerged from my study with appropriate illustrations. Several of the objects discussed appear in the exhibition. The examples may apply to more than one category, but I have chosen to highlight what I consider to be a predominant aspect of their multidimensionality.

a) African art is an art of ideas.

In other words, the form and symbolism of African visual and performing arts point to ideas about the origins of the universe, its divine and human actors, evil, death, and the community. The elaborate masks (see Plate 30) and cave drawings of the Dogon people of Mali were recognized several decades ago as complex cosmological and mythological statements by the French anthropologist Marcel Griaule. For example, he and his associate, Germaine Dieterlen, saw the cross or geometrically decorated pole which tops the famous *Kanaga* mask as symbolizing the equilibrium between heaven and earth, as well as the divine order in the cosmos (Dieterlen 1989). The zigzag motif which appears in Dogon rock paintings and other forms of artistic expression such as masks is interpreted by subsequent researchers as redolent with meaning. Allen Roberts considers that it represents the descent of the ark and the transmission of knowledge and power from the elemental act of a theft of a piece of the sun from God or Amma (Roberts 1988: 70-75). Barbara DeMott argues that the checkerboard arrangement so characteristic of many activities and aspects of Dogon culture, as in the layout of fields and architectural facades, serves in myth as an image of the cosmic completion and the balanced order of human culture. This is expressed through the interlocking horizontals and verticals in the designs (DeMott 1982: 17-19).

Another example of the way that form, particularly abstract or aniconic form, can symbolize important philosophical ideas would be the way the Yoruba employ the cone shape to represent the primal force of *ase* or power. The conical form may be reproduced as the king's crown (see Plate 9), as a design on cloth, or as triangles of cowries and leather panels on the *ibori* or containers for the *ori inu*, or inner head. It serves to distinguish the inner head from its physical counterpart (Abiodun 1987).

A particular art object may convey important cosmological ideas. For example, Fred Lamp sees the Nowo mask of the Sande society (the female version of the male Poro society) in Sierra Leone as a cosmological map of Temne ideas about new life being germinated from the spirits of the dead (Lamp 1985). The raised border of the Yoruba divination tray (see Plate 4) is replete with images which "articulate a cosmos of competing, autonomous forces" (Drewal, Pemberton, and Abiodun 1989: 17). The only constant image on the tray is the face of Eṣu, the divine mediator, who is recognized as the divinity or *oriṣa* who maintains the precarious balance between the benevolent and malevolent forces of the universe (Abiodun 1975: 437-8).

b) African art is transformative.

It is intended to *do* something, whether to help people heal, become adults or ancestors, or stay safe. French scholar Lucien Stéphan maintains that African art objects are more frequently produced *to act* or *to cause action* than *to show* in the sense of to represent (in Kerchache, Paudrat, and Stéphan 1993). Two pertinent examples would be, first, the Kongo *minkisi*, or power, figures (see Plate 2), which have an apotropaic function—to repel evil forces and treat illnesses and misfortune—and, second, the ornaments worn by Senufo women diviners to attract the spirits, or *madebele*, to their consulting room (Glaze 1981).

The world-renowned San (formerly known as "Bushmen") rock art of southern Africa is closely associated with the activities of San shamans or medicine-men (Lewis-Williams and Dowson 1989). Some of this art is considered to be contemporaneous with Upper Palaeolithic Art of Western Europe with more recent paintings dating to the end of the nineteenth century or even later (see Plate 12). The therianthropic forms, or animals with human features, of many of the paintings metaphorically link "dying" shamans to potent but dying animals. Accompanying physical or somatic sensations are depicted as small entoptic dots, zigzags or chevrons, as well as elongated heads. They are believed to represent the interactions between this world and the spirit-world of the shaman-artists, and possibly also the hallucinations experienced after their initial acquisitions of power. When in trance, usually in the course of a trance dance, the shamans were said to perform a variety of tasks such as healing, rain-making, visiting distant camps, and controlling animal populations. The rock face also had its own potency as some of the images disappear into cracks or holes recalling the shamanistic belief that the spirit world is accessed through holes in the ground (Lewis-Williams and Dowson 1990). The paint too was believed to be powerful and often contained eland blood as a source of empowerment.

Ethiopian art provides some wonderful examples of protective and healing devices in the form of icons, seals, manuscripts, talismans, and scrolls (Mercier 1992, 1979). The latter are often strikingly dominated by eyes and faces. At the center is usually the divine face of God, often surrounded by angels, birds, or other

supporters and intercessors set in geometric motifs. Double lines and oversized heads are common features of this magical art. The intimate, two-way gaze is considered to be conducive for exorcism of the possessing spirit. When it sees the talismanic image, the spirit is believed to shout and leave its human host. This visual manipulation is also attributed to the visionary or hallucinogenic experience of many clerics, who have been possessed by *zar* spirits or demons in the course of their therapeutic vocations.

Funerary ceremonies are important contexts for understanding the transformative capacity of African art. Anita Glaze describes the funerals of initiated elders of the Poro secret society among the Senufo of Côte d'Ivoire as "multi-media events" involving a complex configuration of dance, sculpture, colorful costumes, music and song texts (Glaze 1981). This artistic display is intended to communicate a person's status and quality of life but also it serves to ensure his transition to ancestorhood. Glaze notes the significance of employing aesthetic means for dealing with the negative and destabilizing forces associated with the spirits of the dead. Of the masks which come out when a Poro elder dies, it is the "fire spitter," or *kporo,* mask (see Plate 31) which is the most important (Förster 1993). This is a zoomorphic helmet mask which is regarded as the embodiment of the Poro society. It incorporates imagery from various powerful and aggressive animals—antelopes, hyenas, hornbills, crocodiles, and chameleons. The costume and ritual performance serve to distinguish the various Poro associations rather than the mask itself. The masquerader is responsible for going to the corpse and performing the necessary rituals, accompanied by Poro drums, to separate the life force of the deceased from the corpse. The burial then occurs before nightfall. Förster emphasizes the polysemic nature of the mask. It combines seemingly disparate elements of village and wilderness and is thus able to remove the deceased from the human realm, estranging him from his relatives as a lifeless piece of wood. Because of its dynamism and ambiguity, the mask is particularly suited to marking the boundaries and bonds between the various critical phases of life.

c) African art is dynamic.

The process of creation may be as important, if not more important, than the final product. African artists are commonly believed to have special character and status because their creative talents put them close to the spirit world. They may derive inspiration from their dreams or ancestors. Because of the attendant dangers, various propitiatory rituals may have to be performed before a tree is cut down or the iron working process begins. Once the art object has been completed it has to be empowered through rites of consecration and activation. For example, Asante craftsmen invite the disembodied tree spirit back into the talking drum or stool (Rattray 1969 [1927]: 5).

The creative process may be ongoing with owners or caretakers making aesthetic alterations, such as new designs or addition of decorative items. The twin memorial figures, or *ibeji* (see Plate 28), made by the Yoruba are a good example of how art objects may be ritually nurtured over time. They may be washed, oiled, dressed, and adorned with jewelry and clothes in the hope that the living twin may not be called to join its dead counterpart. Masquerades, such as the ancestral *egungun* of the Yoruba, may have cloth added to them by their patrons, and masks may be altered by new pigmentation or objects. Metal altars known as *asen* are used by the Fon of the Republic of Benin to commemorate

their deceased relatives. They are associated with Gun (or Ogun) the patron deity of all those who work with iron. Allen Roberts describes how blacksmiths now recycle old car bumpers and imported brass pipes because the shinier finishes are believed to have greater apotropaic value (Roberts 1996).

Sometimes the choice of a particular material and form may only be understood in light of prevailing religious beliefs. For example, the most powerful symbols of Asante ancestors are blackened stools and not other chiefly accouterments (see Plate 16) such as crowns and jewelry. It is because the wood comes from a tree believed to be the abode of a powerful spirit who may still come and inhabit the carved stool. The latter therefore constitutes the ideal object for the spirit of the deceased chief to enter, in addition to being the stool used by the chief during his lifetime (Sarpong 1971).

d) African art is communal.

While individual artists may be responsible for particular creations or may produce objects because of an individual's needs such as sickness or infertility, African art objects link humans to each other and to the spiritual and natural worlds. The transient shrines, or *mbari,* formerly produced by the Owerri Igbo people of south-eastern Nigeria are a case in point (Cole 1982). They were made as sacrifices to major community gods, usually as a response to serious communal crises such as famine, plague, excessive drought, warfare, or poor harvests. Ala, the earth deity, was generally seen as having inflicted these punishments, and she frequently dominated these sculptural monuments. Following completion of the shrine, which involved singing, dancing, praying, body-painting, as well as sacrifice and initiation ceremonies, it was often left to deteriorate and rejoin the earth.

Initiation arts have a very communal orientation. They may reenact the origins of the world, or of a particular society, or recall the salvific acts of particular ancestors. As part of the initiatory rituals and imparting of social knowledge, the neophytes/initiands are taught the symbolic meanings of masks and performance. This is well illustrated by the various initiation societies of the Bamana peoples. In the case of the *N'domo,* for example, the boys farm a ritual field recalling the time when the Bamana abandoned their nomadic life of hunting. The preparation of the masks is associated with fertility and germination, and their dances link the initiates with the forces of life and death (Zahan 1960: 43). Among Bamana women it is *Basiae* or *N'Gale* mud-cloths with their complex circular motifs which mystically and symbolically link the initiated girls with their older women sponsors. The cloth is worn at critical transitional moments of a woman's life, notably following excision, and is believed to be so charged with *nyama* or spiritual power that only those close to the realm of the dead can wear or look after it (Brett-Smith 1982).

Ancestral art can be a powerful statement of communal values. The Fang peoples of Cameroon and Gabon believe that the dead are able to transfer their blessings to the living. Ancestral relics were kept in containers surmounted by a head or statue figure. These magnificent carved figures served not just as guardians but also as a focal point of initiation ceremonies, challenging the opposition between the universes of the living and the dead (Laburthe-Tolra and Falgayrettes-Leveau 1991). They emanate qualities of "protective benevolence" as well as maturity and secret knowledge (Fernandez and Fernandez 1976). But they also have

an infantile appearance with their large heads, wide staring disc eyes and flexed small legs. Moreover, they were treated as children prior to the ceremony while they are being cleansed with palm oil before receiving requests from the living. As in other parts of Africa, "little people" such as pygmies, dwarfs, and trolls are believed to mediate between the material and spiritual worlds. This ambiguous combination of mature and infantile qualities is also indicative of Fang values of "composedness," even-handed tranquillity, and the ability to hold opposites in tension. Production of these ancestral figures for ceremonial purposes had virtually ceased by the 1970s. As the statues were less valued by the Fang than the ancestral skulls that the figures protected, it proved fairly easy for foreigners to acquire them.

e) African art involves complex ideas about embodiment and representation of the spirit world.

In the past, scholarly analysis has played down the "animistic" qualities of African art objects, so as not to appear to be endorsing the negative stereotypes of Africans being unable to distinguish between material objects and immaterial forces. As a result it has failed to explore the complexity of the perceived relationship between spirit forces and material hosts, or the difference, in Blier's terms, between "actual" and "representational" power (Blier 1995). Yet created objects are rarely held to embody spiritual power in their own right—rather they must be activated in some way. This may be done once or several times, through sacrifice, speech, heat, or accumulation of materials. In some cases, as with particular masks, it is believed that they accumulate power over time and through use.

One scholar who has insightfully examined the attribution of personhood to ritual objects is Wyatt MacGaffey (MacGaffey and Harris 1993). He has written extensively on Kongo *minkisi*, or power objects (see Plate 2), which are mistakenly labeled as "fetishes." Reversing the argument from Westerners that Africans fail to distinguish adequately between people and objects, MacGaffey suggests that it is a dubious distinction which displays Western preoccupations with commodification. He further demonstrates that the Kongo treat the objects *as if* they were persons by virtue of the medicines they conceal and not because they resemble some empowering spirit. People respond to the objects because of what they *do* not what they *represent*. They are not intended to look like the empowering spirit, nor were they intended for contemplation as art. This recalls Robert Plant Armstrong's preference for describing the aesthetic in terms of *power* rather than *beauty*. He distinguished between works dependent on external power and those with their own internal energies (Armstrong 1981: 5f.). In similar vein, Rowland Abiodun argues that *ase,* or power, is integral to the Yoruba aesthetic—it imbues sound, space, and matter with energy to restructure existence and transform and control the physical world (Abiodun 1994).

Masking has perhaps generated the most discussion over issues of spirit representation and embodiment. The ambiguity of masks and their symbolic capacity to reverse what is normal, i.e. humans are normally visible and spirits are not, account for their frequent use in rituals of transition, namely initiation and death. Through the use of non- or super-human features and costumes, as well as rites and performance, mystical transformation is connoted. Based on his work on Ebira masquerading traditions in Nigeria, John Picton develops a typology of masks which does justice to the nuances of metaphysical and identity transformation. He suggests that among the Ebira there is a tendency for masks to lose their spiritual meanings and become more secularized as entertainment. However, he also notes that some masks develop their own healing potential and may be treated as shrines rather than masks (Picton 1990).

f) African art may conceal more than it reveals.

In other words, what is central, public, and most decorated may not be where the power lies (see Nooter 1993). The most spiritually powerful objects may be hidden from public view in a shrine and only seen and used by ritual specialists. Or, as in the case of Vodun *bocio,* or empowering sculptural figures, so richly described by Suzanne Blier (Blier 1995), it may be the base form or hidden part of the figure which determines the object's power and use. Sculptures with pointed bases are driven one time only into the earth from which the trickster deity, Legba, derives his power. Those with plinth bases can be activated several times.

> What is central, public, and most decorated may not be where the power lies. The most spiritually powerful objects may be hidden from public view in a shrine and only seen and used by ritual specialists.

In this regard, our aesthetic perceptions may be challenged. For example, the large Bamana sculptures known as *boliw* have an unpleasing appearance. They resemble cows, human beings, or round balls. They conceal magical ingredients beneath a thick black coating of poisonous feces. Sequestered in a sacred grove and seen only by high ranking elders of the secret society, they are the most revered objects of the Bamana because they assemble and condense the poisons the Bamana fear most. Furthermore they reverse normal processes by putting feces on the outside and wrapped cloths or "skin" associated with childbirth on the inside (Brett-Smith 1983). The Mafa and Bulahay of northern Cameroon believe that excessive decoration may impede the flow of spiritual power from out of and into their *Zhikile* or "God pots." Other pots are made with insulating designs which serve to trap the spirits inside (David, Sterner, and Gavua 1988: 369).

Sometimes it is concealed medicines under a crown or behind a mask which turn it into a spiritually charged object and increase, in Robert Plant Armstrong's words, its "affecting presence." Nii Quarcoopome's work on Dangme stools and altars in southern Ghana demonstrates that these emblems of power do not have to

have an elaborate form to serve as contact points with the spirit world because they provide "visual metaphors" for their "nonvisible qualities" [1993:116]. These innate powers derive from the additional components, such as herbs, animal and human relics, the annual rites of consecration, and the permanent concealment (of the stools) in darkness.

In her studies of Senufo masquerades in Côte d'Ivoire, Anita Glaze shows how the interpolation of female-oriented symbols in the male-controlled performative space conveys values of motherhood, female beauty, continuity, unity, and productivity. In addition to the saving, healing and redemptive powers of women their mediatory role is symbolized by the chameleon which carries messages from land spirits to the spiritual realm, just as women diviners in the Sandogo Society link the individual to land-spirit messengers to God. Glaze's iconographic analysis of Senufo masquerades interestingly demonstrates that the closer the relationship with the spiritual realm, the more secretive objects and events become, and the greater is the role of women (Glaze 1986, 1975) (see, more generally, Hackett 1998).

g) African art can reveal important religious continuities and changes.

In addition to constituting a primary source for understanding religious ideas, artistic form, and practice may provide important evidence of religious change, continuities, and interactions in contemporary Africa. The Dogon of Mali have long been subject to the scrutiny of scholars and tourists because of their elaborate masked dances and festivals. Van Beek's work on the Dogon illustrates well how they continually introduced changes–whether new masks, myths, divination techniques, or performance innovations–which are soon regarded as "traditional" (Beek 1991).

Bwiti, the new religion forged out of the encounter between Christianity and Fang culture in Gabon, provides some fine examples of religious and artistic creativity. Seen by some as a revitalization movement in the face of missionary and colonial opposition, it has its roots in ancestral cults but has become increasingly Christianized and feminized (see Fernandez 1982; Swiderski 1989). Having reversed feelings of cultural inferiority through the incorporation of new artistic techniques and colors, and new theological and philosophical concepts derived from its contact with European culture, Bwiti is now regarded as the "official" art of Gabon.

The many Christian churches which have taken root in Africa vary in the extent to which they draw on more "traditional" art. The Roman Catholic Church was one of the earliest to promote the work of African artists for liturgical purposes. Newer evangelical and pentecostal groups are more fearful of their "traditional" cultural heritage and its purported "satanic" underpinnings. They may limit their use of (generally Christocentric) art to evangelism and education. Individual artists, such as the Namibian John Ndevasia Muafangejo, who was trained at the Lutheran Rorke's Drift Art and Craft Centre in Natal, South Africa may provide a vivid visual record of the changing religious and political experiences of their people (Danilowitz 1993). Muafangejo's striking black-and-white visionary linocuts depict not just racial polarities but also the church's growing role in popular resistance.

Ali Mazrui contends that a divergence exists between Islamic and African aesthetics because of the uncompromising emphasis of Muslims on monotheism, and an ancient distrust of idolatry (Mazrui 1994). He argues that it is in the area of music, poetry, architecture, and calligraphy that Islam encounters African cultures. However, René Bravmann claims that masking and figurative traditions have long co-existed with Islam in parts of West Africa, such as among the Mande and the Asante (Bravmann 1974). There is evidence of Islamic symbols and Arabic inscriptions being incorporated into textile patterns, and other forms of adornment. This was an indication of the power and knowledge associated with Islam by non-Muslims.

It is perhaps in the realm of the popular arts that the growing presence of Islam can be noted. "A Saint in the City: Sufi Arts of Urban Senegal" is an exhibition program, at the Fowler Museum (UCLA), created by Allen Roberts and Mary Nooter Roberts concerning the arts of the Mourides, a Sufi movement originating in Senegal. It has a stunning web site (http://www.fmch.ucla.edu/passport/home.html/passport/exin.him) which allows the visitor to appreciate how religious devotion for an African Sufi saint, Amadu Bamba, is expressed in popular art and music, and travels via members of the movement who are frequently traders. Events from Bamba's life and his only photographic image (1913) are depicted by local artists on glass paintings (which spread from Islamic North Africa) (see Plate 59), murals, plaques, and numerous other media such as photocopies, banners, devotional literature, and web sites.

A number of artists do not want to be classified as belonging to any particular religion and have instead sought a synthesis of different religious paths. Simon Ottenberg's research on contemporary eastern Nigerian artists examines the way in which they use the visual arts to reconcile internal and external religious influences in their lives (Ottenberg 1994). Boniface Okafor's paintings communicate his interests in a more universalist and religious pluralistic message. Egyptian motifs appear in his work because of his association with the Rosicrucian Fellowship. The well-known Kongolese artist, Chéri Samba, has produced a number of popular Mami Wata paintings which depict the seductive water spirit whose cult extends from Senegal to Angola {Jewsiewicki, 1995 #1411}. A cult of possession, it promises worldly success but also social destruction. Since it is often associated with modernity while incorporating many indigenous ideas, the rich eclectic imagery draws from Hindu, African, European, Christian, American, and occult sources (Drewal 1996).

CONCLUSION

My concern in this essay has been to say something about what is gained by approaching African art with greater attention to its religious and spiritual dimensions. One does not have to be an expert in theology or philosophy or comparative religion to appreciate that there is more to the African visual and performing arts than meets the eye. Examples include the myth of creation that the artist has in mind when he or she gives form to a piece of wood or the dream from the ancestors that inspired the design for a cloth, or a society's belief that one cannot represent the divine in material form and so must look for symbolic alternatives. Religious ideas might also determine the choice of color for a masquerade, such as white to connote spiritual coolness, or the movement of a dancer possessed by an aggressive spirit. In sum, African art can teach us to see artistic form and practice in new and exciting ways whether we are museum-goers, tourists, collectors, curators, academics, spiritual pilgrims, or artists. ▮

Leadership and Status

This section focuses on the assertions of status associated with leadership. Throughout Africa the position of an individual in society is declared through personal adornment (body markings, hair arrangement, dress) and the accoutrements they display. Gender, age, membership of a group, and accomplishment are all declared in these ways. Although status, ranking, and power are a part of these visual displays, the most elaborate visual presentations are associated with those in positions of leadership. Leadership ranges in Africa from non-centralized groups where control is more democratic, to centralized systems ranging from lineage systems, to chiefdoms, to enormous kingdoms or states. Art has been used to support the authority of both sacred and secular leadership around the world. In Africa the political and religious are often combined and the rich, complex, multi-meaning nature of leadership arts is used in a surprising number of ways. Divine kingship combines both political and religious elements. Although these kings, while alive, are not yet deities, they are seen as the primary link between the human world and the world of the spirits.

Some leadership arts are owned by individuals, and others are only held in trust and considered to be the property of the state. Leaders commission art, and the finest craftsmanship and artistry are seen in their regalia and accoutrements. Leaders also distribute art, use art to send messages, and use it at various times to affect change or maintain the status quo. Certain art is purposefully displayed for the general population, while some is hidden, to be seen only by the elite and the spirit world. The materials of manufacture for leadership arts are often symbolic of the status, power, and wealth of their owners. Expensive materials such as copper alloys (brass and bronze), silks, and beads are typical, and may be restricted to royal use exclusively.

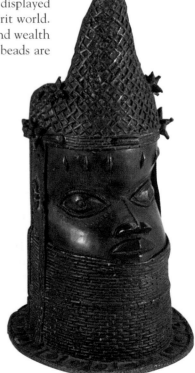

Personal adornment arts are represented with the beautiful, luxurious kente cloth used by Asante royalty; the beaded crown of the Yoruba kings (and its adaptation into a Santeria crown of Yoruba descendants in the New World); the magnificent embroidered gown of the Hausa theocracy; and the towering hat of the Ekonda chief. Accoutrements of power include the Benin gong, the ceremonial Ekonda sword and Luba spear. Stools and thrones elevate, isolate, and give prominence to leaders, and are represented by the Bamileke beaded stool and the Asante *akonkromfi* chair. The importance of animal symbolism is seen in the Bamileke stool for the power of creatures such as leopards and elephants is frequently equated to that of kings and chiefs. Architectural embellishments are represented by a door from a Yoruba palace. Royal shrine accoutrements are represented with the Benin Queen mother memorial head. The importance of women in political life is declared through examples such as this and the Luba spear adorned with a female figure. Prior to colonial rule and the imposition of modern political and state systems, such leadership arts were more prominent, but they have not disappeared. Traditional leaders still retain much ritual and religious clout as well as judicial and political power. ▌

The exhibition is organized into the following themes: Leadership and Status, Death and the Ancestors, Utility and the Art of Living, Transitions and Dealing with Adversity, and Connecting with the World.

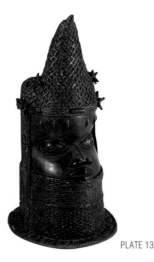

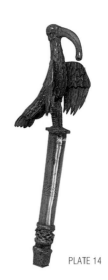

PLATE 13

PLATE 14

PLATE 13. Commemorative Head of a Queen Mother (Iyoba)

Benin kingdom, Edo peoples, Nigeria, probably 18th century
Copper alloy, clay
H x W x D: 47 x 23.7 x 26.6 cm (18 1/2 x 9 5/16 x 10 1/2 in.)
The Field Museum, Chicago
8149
Photograph by Diane Alexander White
Negative #A114184 1c

Sacred or divine kings, known as *obas*, have ruled the Kingdom of Benin in south central Nigeria for more than six hundred years. Benin produced the largest body of art (including figures, heads and plaques) cast in copper alloys, known in all of sub-Saharan Africa. It is through this art, now in public and private collections throughout Europe and America, that Benin is best known to the outside world. In 1897 the notorious Benin Punitive Expedition mounted by the British Navy, destroyed much of the royal palace, looted thousands of these art objects, and exiled the king. The kingship was reinstated in 1914 but the art was never returned. While much of Benin royal art was made for the king who was politically and ideologically of central importance to the kingdom, women were also honored. This head depicts a queen mother, commissioned by her son, the *oba*, on her death and placed on an altar devoted to her commemoration.

According to oral tradition the title of Queen Mother (Iyoba) was instituted by Oba Esigie, the sixteenth king who probably ruled in the early 16th century. His mother, Idia, is principally remembered for aiding her son to triumph over rival claimants to the throne, and her military acumen in her son's war with the Igala people. She was given her own palace, in the village of Uselu, just outside the city, and functioned as a chief over her own district. In return for allowing his mother to have this honor, the Edo (people of Benin), stipulated that Esigie should never have contact with his mother again (except through intermediaries). Esigie is also credited with establishing on her death an altar to her memory in his own palace, and beginning the tradition of casting this type of brass head. The tradition has continued since that time (Ben-Amos 1983, Girshick Ben-Amos 1995).

Brasscasting was (and is) done by a guild of professional artists who had completed an extensive apprenticeship and worked (in precolonial times) under the almost exclusive patronage of the *oba*.

Brass has a complex symbolic meaning in Benin. As a material that never rusts, it stands for permanence and continuity of kingship. Its shiny surface is considered beautiful. And in the past the royal brasses were constantly being polished to a high sheen. Lastly, brass is red in color and this is considered by the Edo to be "threatening," that is, to have the power to drive away evil forces (Girshick Ben-Amos 1995:88).

This head probably is from the 18th century when metal became more plentiful and the heads became heavier and larger than those made earlier. Facial features became larger and more standardized in this period also. The Queen mother wears a beaded collar that extends up over her chin, and a crown in the distinctive pointed form reserved for the Iyoba. It has been identified as either a chicken's or a parrot's beak (Kaplan 2000). The beads on the collar and crown are meant to represent those in coral, which were the exclusive prerogative of the king, the queen mother and a few other high ranking chiefs. A figuratively carved ivory tusk would have once been placed at the back of the head (Blackmun 1991).

PLATE 14. Idiophone[1] of an Ibis (Ahianmwen-oro)

Benin kingdom, Edo peoples, Nigeria, probably 18th century
Copper alloy
H x W x D: 31.3 x 9 x 9 cm (12 5/16 x 3 1/2 x 3 1/2 in.)
The Field Museum, Chicago
210327
Photograph by Diane Alexander White
Negative #A114184 6c

This brass bird staff is also associated with the reign of Oba Esigie, one of the great warrior kings of the 16th century. As Esigie was setting off to go to battle with his enemy, the Igala, a bird of prophecy (Ahianmwen-oro) appeared predicting disaster. Rather than believe this omen of doom, Esigie had the bird killed. After a great battle Benin was victorious and Esigie had his brasscasters make an image of the bird into a staff and proclaimed, "whoever wishes to succeed in life should not heed the bird of prophesy" (Girshick Ben-Amos 1995:35). The battle with the Igala may well have been over control of the northern trade routes along the Niger River.

The prophecy bird gong is used annually during the Ugie Oro festival. This festival was created by the sixteenth century king Esigie in remembrance of his great defeat of the Igala. Girshick Ben-Amos explains that it occurs in the annual cycle of ceremonies after a ritual that augments

[1] An idiophone is the technical name for percussion instruments of resonating material (e.g. gongs, bells and rattles), as opposed to those with strings (chordaphones), use air (aerophones), or are drums (membranophones).

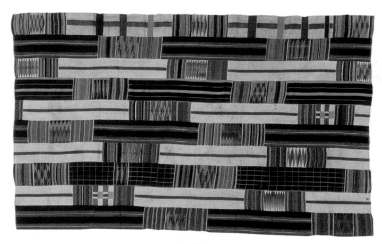

PLATE 15

the power of the royal relics, the core of the monarchy. Ugie Oro follows. Every five days for the next three months, the king and chiefs dance in procession, outdoing each other in lavishness of dress. It is considered so attractive of a festival that, in the Benin adage, "If a farmer participates in dancing Oro he will never take care of his farm." As part of the ceremony, chiefs dance in a circle, beating with a rod the beak of a cast brass bird in remembrance of the prophetic bird Oba Esigie had killed on his way to success against the Igala people....This commemorative element appears to have been grafted by Esigie on a basically ancestral rite started by an earlier king, Oba Ewedo, since throughout the period sacrifices are made to the royal ancestors, a foreshadowing of the main ancestral rites to come (1995:101).

PLATE 15. Wrapper (Kente)

Asante peoples, Ghana, 20th century
Cotton, silk
H x W: 132 x 88.3 cm (51 15/16 x 34 3/4 in.)
National Museum of African Art, National Museum of Natural History, Smithsonian Institution
Purchased with funds provided by the
Smithsonian Collections Acquisition Program, 1983-85
EJ10597
Photograph by Franko Khoury
Photograph © National Museum of African Art, Smithsonian Institution

Cloth of this type, from the Asante people of Ghana, is known as kente. This kente is made of cotton and silk (the latter a material only the wealthy could afford), and the technical skill to construct it clearly shows why the Asante have a well-deserved reputation as some of the finest weavers in the world. The cloth is woven in narrow strips (approximately 3 to 3 1/2 inches wide) on treadle looms by men. The strips are then sewn together, edge to edge (this piece has ten panels), into the large piece of cloth that is most commonly used for a piece of clothing known as a wrapper. Women wear two pieces, as an upper and lower wrapper. Men wear one long piece, wrapped around the body, draped over the left shoulder then wrapped around the body again and tucked in to produce a toga-like effect. This type of kente cloth is known as *Mmaban* (mixed) and has five different warp stripe designs (most have only one). The diagonal placement of the decorative blocks is unusual, as the elements of most kente cloth are arranged in checkerboard fashion. The yellow supplementary thread was probably unraveled from imported silk cloth and makes a dramatic contrast to the dark blue and white blocks of color (Ross 1998:296, Gilfoy 1987: 79).

Kente cloth is without doubt the most popular and best known of all African fabrics. The most elaborate and costly varieties were once the exclusive prerogative of the Asante king, or Asantehene, and his chiefs. One very rare type, known as Asasia cloth is

the exclusive prerogative of the Asantehene and those he designates. They were originally woven by a single family of weavers in Bonwire [however it was feared the skill had been lost, but]...as recently as 1997, [Ross] was told that there were actually several weavers capable of producing Asasia and that only commissions from the Asantehene or other entitled chiefs were lacking (Ross 1998:81).

Now kente is produced in greater quantity, sold to more clients (Ghanaian, African, and American) and incorporated into more items than any other African textile. In the United States it has become a symbol of African American pride and identity. Stoles are the most commonly seen item and are frequently used by African American churches, and college fraternities and sororities. In Ghana, kente is a high status fabric worn on special occasions. The most important occasions are the Adae Kesee festival for the entire nation, and durbars or public parades of chiefs at their local courts. During these events the regalia of the state and chiefdoms are displayed. Periodically the chiefs stand up on palanquins or litters carried by their retainers and dance, flashing their gold jewelry and swirling their colorful kente cloths for appreciative subjects. Funerals are not a time for wearing kente cloth. Dark red *adinkra* cloth (see Plate 25) is appropriate in that setting. To honor the deceased, however, the corpse will be dressed in kente (Ross 1998: chapter 3).

The names of kente cloth show rich variation.

Some cloth names are derived from the names of people, normally rulers....Some patterns were known by more than one name, and some were said to be worn only in particular circumstances which gave them their names: for example the cloth called *Amanahyiamu* ("the nation has met together") was worn by the Asantehene at the Odwira festival. Other cloth names were linked to particular historical personages....The famous cloth *adwineasa* ("skill is exhausted" or perhaps "end of art") is named because of the complexities and intricacies of the weaving involved (McLeod 1984:155-6).

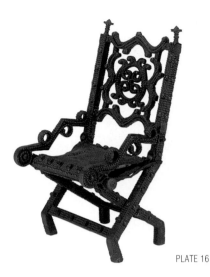

PLATE 16

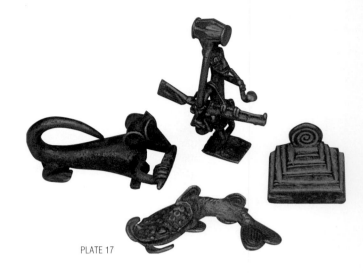

PLATE 17

PLATE 16. Chair (Akonkromfi)

Asante Akan People, Ghana, probably mid/late 19th century
Wood, leather, brass
H x W x D: 96.5 x 61 x 53.3 cm (38 x 24 x 21 in.)
The Art Institute of Chicago,
Restricted gift of Jamee J. and Marshall Field
2000.347
Photograph by Robert Hashimoto
Photograph © The Art Institute of Chicago

The Asante, of all the Akan-speaking peoples, have developed and elaborated upon their state arts and regalia to the greatest extent. This richly embellished and ornate chair visually proclaimed the power and grandeur of the chief or royal who sat on it. As was the case for most Asante regalia, however, it was not individually owned but belonged to the state or local chieftaincy. It was therefore as much a statement about the political authority and financial superiority of the Asante institution of leadership as it was of the individual using it. This chair type, known as *akonkromfi*, is one of three chair types (along with *asipim* and *hwedom*) that seem based upon seventeenth or early eighteenth European chairs. They have been locally made for centuries and clearly have been adopted and transformed into quite typically Asante items. The name *akonkromfi* means "praying mantis," perhaps because of the insect-like articulation of the legs. The x-form of the legs suggests a folding chair proto-type though the Asante examples do not fold. These chairs are typically ornamented with brass-headed nails and other variously-shaped pieces of brass, and the backs typically have elaborate open-work forms. The *akonkromfi* and *hwedom* chairs are larger and have greater importance and prestige than the smaller *asipim* chairs. The *hwedom* is associated with judicial duties of the cheftaincy and was used when declaring war. The *akonkromfi* was associated with festive occasions (McLeod 1981:118-124, Cole and Ross 1977:140-143).

Although these European chairs signify prestige and wealth, they have no spiritual significance to the Asante. Among Akan peoples, and particularly the Asante, it is the much older furniture form, the stool, that has great ritual importance. A stool

was not only considered a highly personal item; it was also believed to house the soul of the owner. When unoccupied the stool would be tipped on its side so that no alien force could occupy it and thus contaminate the owner's soul. The stool of a chief was of particular importance, not only because it was the repository of his soul, but because the chief was considered to be a divine king, and one aspect of his divinity was the belief that the well-being

of his kingdom directly reflected the well-being of his soul. The king's soul had thus to be protected from spiritual contamination in order to ensure the prosperity of the kingdom. After the death of a king, his stool was preserved in an ancestral shrine, both to commemorate the deceased and to house his soul. The stool thus functioned much as ancestor figures did in other cultures (Sieber 1994:31).

The stools of chiefs were considered so important that they often had, and were only stored on, their own *akonkromfi* or *hwedom* chair.

PLATE 17. Goldweights

Akan People, Ghana or Côte d'Ivoire (Ivory Coast),
18th/ early 20th century
Copper Alloy
H (max): 5.1 cm (2 in)
The Art Institute of Chicago,
Clockwise from top:
Gift of Mr. and Mrs. Philip Pinsof
1979.530
Restricted gift of Mr. and Mrs. Raymond Wielgus
1977.39
Gift of Alfred Wolkenberg
1966.82
Gift of Raymond E. Britt, Jr.
1978.891
Photograph by Robert Hashimoto
Photograph © The Art Institute of Chicago

PLATE 18. Equipment for weighing gold dust

Akan peoples, Ghana or Côte d'Ivoire (Ivory Coast),
18th – late 19th century
Copper alloy
Scoop: Gift of Cynthia E. Gubernick, 70-20-81
Scale: Gift of Mr. and Mrs. Robert Bevill, Mr. and Mrs. Alan Bresler and Mr. and Mrs. Gilbert Schulman, 75-22-1
Beetle weight: Gift of Mr. and Mrs. Robert Bevill, Mr. and Mrs. Alan Bresler and Mr. and Mrs. Gilbert Schulman, 75-22-575
Peanut weight:Gift of Robert B. Dean, 76-51-7
Oval box: Gift of Cynthia E. Gubernick, 70-20-54
Square box: Gift of Benjamin Weiss, 80-28-18
National Museum of African Art, Smithsonian Institution
Photograph by Franko Khoury
Photograph © National Museum of African Art, Smithsonian Institution

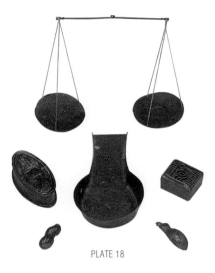

PLATE 18

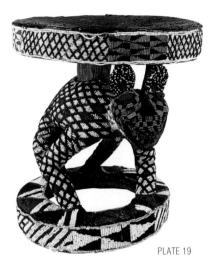

PLATE 19

Trade, especially trade in gold, was essential to the development of the powerful states and kingdoms of the Akan speaking people of southern Ghana and Côte d'Ivoire (Ivory Coast). Before the arrival of Europeans along the west African coast beginning from the 15th century on, trade was largely directed to the north through peoples of the Sahel region, then across the Sahara to north Africa. Gold was not only an item of trade but was also this area's currency in precolonial times and the equipment seen here exemplifies the type of tools used to weigh the gold and transact business. Simple balance scales were used with counterbalancing goldweights to weigh the gold dust and nuggets, mined in the area's alluvial goldfields. Early weights were mostly geometric and non-representational in design and were calibrated to Islamic systems of weights. Later the weights were made into European units of measurement (Garrard 1980). Figurative goldweights became more popular in the 18th century but even then geometric forms (whether in Islamic or European weight units) were the most numerous type.

The weights were modeled in wax and then cast into metal (almost always a copper alloy) using the lost wax method of production. Occasionally actual items, such as the beetle and peanut shown here, were invested with the clay mold material and burnt out before the molten metal was poured into the resulting hollow mold. Hence this method is sometimes called the "lost-beetle" method of casting. A gold-weighing set (called a *futuo*) consisted of: a cloth and animal skin to lay all the tools out on (and catch any dropped gold); spoons to transfer the gold (so none of the dust would stick to one's fingers); a blowpan, such as seen here, where gold dust would be placed and blown across to remove impurities; gold dust containers; the scales; and a set of 30 to 40 goldweights of varying sizes. In precolonial times (gold ceased as the currency of exchange around 1900) a young man of marriageable age was given such a set by his father with the expectations he would be able to support a family through his trading activities. The tens of thousands of goldweights still in existence mostly were the tools of such individual traders. Another use was seen in the much larger and more elaborate sets that were kept in state treasuries. Partly displayed as symbols of the wealth and prestige associated with the powerful kingdoms, they also had practical uses, since the levies, taxes and fines that funded the state systems were paid in gold-dust (McLeod 1981:125). Boxes for keeping gold were often either cast or fabricated from sheet metal.

Akan culture is characterized by what Herbert Cole calls a "visual-verbal nexus" (2001:195), where there is a dynamic interaction of visual motifs and verbal expressions. It is not surprising therefore, that although the goldweights exhibit a wide range of subject matter, many seem to be illustrative or symbolic of proverbs. Some of the proverbs that were intended when the weights were made are now forgotten, but many are evocative of proverbs that are still commonly used. Some images could elicit multiple proverbs, at times of divergent or opposing meanings, for the Akan delighted in and highly admired verbal play and eloquence. Some examples using the illustrated goldweights can serve as examples. Quarcopone (drawing upon Rattray's 1916 compilation of Asante proverbs) suggests that the catfish may be a symbol of longevity, since they survive the most extreme conditions. Or, it may be evoking the proverb "'If the catfish [mudfish] in the stream grows fat, it does so for the benefit of the crocodile' which means the master always stands to gain from the servants prosperity" (Quarcopone 1997:145). The hunter with a gun, carrying a keg of gunpowder and smoking a pipe, may be a metaphor for the power and audacity of the goldweight's owner. Conversely it also evokes a different proverb "(fire and gunpowder do not sleep together)—suggest[ing] that a lack of circumspection can have dangerous consequences" (ibid. 144). Cole and Ross point out that goldweights of peanuts (called groundnuts in Ghana) often refer to proverbs about marriage such as "'marriage is like groundnuts: you must crack them to see what is inside'...or, you can't tell what marriage is like until you've tried it" (1977:79).

PLATE 19. Beaded stool

Bamileke peoples, Cameroon, early 20th century
Wood, glass beads, plant fiber fabric, resin
H x W x D: 57.5 x 56 x 58 cm (22 5/8 x 22 x 22 13/16 in.)
The Field Museum, Chicago
175560
Photograph by Diane Alexander White
Negative #A114184 4c

In mountainous western Cameroon, an area commonly known as the Cameroon grasslands, rulers called *fons* head numerous kingdoms. These rulers are considered to be divine, and are both the secular political, and religious leaders of their people. While historically there were rivalries between the various kingdoms, there was also extensive internal trade and political interchanges. This contributed to a distinct Cameroon grasslands style which shared many motifs and styles. Much of grasslands art was made for the nobility and included impressive palaces filled with royal treasures

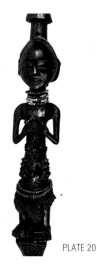

PLATE 20

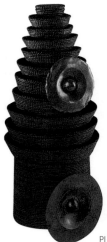

PLATE 21

of such items as drums, figures, masks, textiles, and regalia, including, most importantly, thrones. This beaded stool (or throne) was for the *fon* or king of one of the hundreds of Bamileke kingdoms in the southern part of the grasslands area.

Stools are used by many people in Bamileke society, but such highly embellished ones as this example, are reserved for the exclusive use of the kings. It is carved of one piece of wood and covered with a plant fiber fabric, to which the multitude of glass beads is sewn. The stool's supporting figure represents a leopard, with the triangular and diamond bead patterns depicting its spots. Northern notes that in the "cultural ambience of the Grassfields chiefdoms with their emphasis on power and leadership, the leopard's strength, power, speed, and cunning symbolize survival and mastery of the environment. The leopard is an animal fit for a king" (1984:44).

Royal stools or thrones were occasionally given as gifts to visiting dignitaries, but usually kept among the treasuries of the palace. Each new king has new thrones and stools made upon his ascension, for that of his predecessor contains the life force of his ancestors and cannot be sat on. Homburger, commenting on beaded stools, notes,

> The significance of such decoration can only be appreciated if one is aware of the extraordinary value of these glass beads—a value derived from the need to import them from distant places. Most of the thrones decorated in this manner were, accordingly, for the use only by kings and courtiers. Even today, in various kingdoms, these thrones are still used in important ceremonies. Many of them were never intended as seats but rather to acknowledge the memory of deceased kings or their wives or mothers. At funeral ceremonies, they were openly displayed in the square in front of the palace (1994:88).

PLATE 20. Royal spear

Luba peoples, Democratic Republic of the Congo (formerly Zaire),
early 20th century
Wood, iron, glass beads, shell, cloth, resin
Detail, overall H x W x D: 163 x 7 x 8 cm (64 3/16 x 2 3/4 x3 1/8 in.)
The Field Museum, Chicago
210462
Photograph by Diane Alexander White
Negative #A114184 8c

Spears are the most common weapons of Africa, but the inclusion of a delicately carved figure of a refined and elegant woman in the middle of this spear shaft, mark it as being extremely rare. It is a

royal spear and one of the most sacred items of a Luba king's treasury. Carefully hidden away from the public eye, such spears are only displayed for special occasions. They are symbols of legitimization along with the staff of office and the royal stool. These spears are also used in the investiture ceremonies of new kings, a series of rituals that incorporate the myths of origin of the Luba kingdom (Nooter Roberts 1995). These tales revolve around Mbidi Kiluwe, a mysterious hunter from the east who introduced the institutions of kingship to the Luba people when they were ruled by the despotic Nkongolo. Mbidi Kiluwe has a child with one of Nkongolo's sisters and it is this son, Kalala Ilunga, who implements the new sacred kingship system. He is considered the founder of the Luba state and the first king. As part of the *kutomboka* dance in the investiture, a reenactment is staged in which Nkongolo

> invited his nephew Kalala Ilunga to perform a dance over a concealed pit planted with upright spears. But Kalala Ilunga, forewarned by a diviner, detected the pit with his own spear as he was dancing and thus foiled Nkongolo's plan for his destruction. (Dewey and Childs 1996:76)

In the final ritual of the investiture the candidate is taken to the site of Kalala Ilunga's first capital and seated on a royal stool.

> The new king now held the spear in one hand and the copper ax in the other. The *twite* [an important titled official] then cried out, *Ke tu komena manyundo* ("Let us strike the anvils") and, raising his two fists in the air, proceeded to beat the bared knees of the king. "May you be firmly fixed in the kingdom," he added, beating again, "and live and reign as long and as well as your illustrious ancestor Kalala Ilunga Mwine Munza," then, adding the long list of praise names always associated with Kalala Ilunga: "I do this to remind you that your forefather Kalala Ilunga introduced ironworking into this land. He was a wise man. Whether weapons of war or tools of peace, whether for arrows and spears or for axes and hoes, the anvil is the secret of power and progress. Remember your people, do not be satisfied merely to take their tribute, give them of your wisdom and of your protection and the success of your kingdom will be assured." (Womersley 1984:71)

Like a blacksmith's transformation of unformed iron into an object of art or utility, so the once common man is transformed into a king (Dewey and Childs 1996:64-66).

Female figures predominate in Luba royal sculpture. Women held important political positions and helped extend the Luba kingdom through intermarriage with outlying chiefs. Women are also the only humans strong enough to be the vessel for the spirit of former kings and thus can act as a bridge between the world of the living and the spirits. The gesture of holding the hands to the breast is to show that these powers are secretly held within the woman's breasts (Nooter Roberts and Roberts 1996).

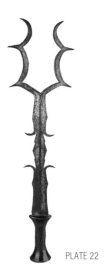

PLATE 22

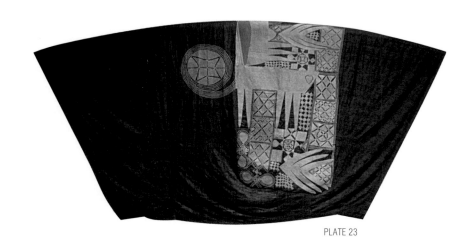

PLATE 23

PLATE 21. Hat (Botolo)

Ekonda, Democratic Republic of the Congo (formerly Zaire), early 20th century
Raffia, brass, copper, dye
H x W x D: 55.2 x 23.2 x 23.6 cm (21 3/4 x 9 1/8 x 9 5/16 in.)
National Museum of African Art, Smithsonian Institution
Museum Purchase
95-11-2
Photograph by Franko Khoury
Photograph © National Museum of African Art, Smithsonian Institution

PLATE 22. Ceremonial Blade

Ekonda, Democratic Republic of the Congo (formerly Zaire), early 20th century
Iron, wood, kaolin
H x W x D: 52.2 x 14.2 x 4.1 cm (20 9/16 x 5 9/16 x 1 5/8 in.)
National Museum of African Art, Smithsonian Institution
Museum Purchase
95-11-3
Photograph by Franko Khoury
Photograph © National Museum of African Art, Smithsonian Institution

This elaborate hat (*botolo*) and ceremonial sword, or blade, are both emblems of office for the ritual chief (*nkumu*) of the Ekonda people who live in the northwestern region of the Democratic Republic of the Congo. Blacksmiths throughout this area were skilled at making a variety of shapes of weapons (Westerdijk 1984). Some may have been used as currency for such special purposes as bridewealth payments, others, such as this example, were for ceremonial display. The Ekonda and many of their neighbors delighted in making non-functional blades with bifurcations, prongs, and scrolls embellishing them, as if their blacksmiths were pointedly boasting of their prowess. From the ritual kaolin (fine white clay) still adhering to this example, and photographic evidence of Ekonda chiefs (*nkumu*) holding them, we know that this type was an emblem of that position.

This hat (*botolo*) along with a special stool, are also emblems of the village chief (*nkunu*) (Arnoldi and Kraemer 1995, Nicolls 1999). Although he shares political power with others, he is still the most important in the socio-religious realm. With the power of the ancestors behind him he is in charge of numerous ritual functions and divination. If a chief is the first in his line he must have a hat made, but as the office is often hereditary it is often passed down from generation to generation. The hat is constructed of raffia and cane fiber using basketry techniques, into a tall cylindrical form.

The horizontal flaring elements (eleven in this case) are added, giving it a form reminiscent of pagodas. Circular brass disks, an emblem of wealth and prestige, are added to the front and occasionally to the top and back. In the 1940s when brass became scarce, a row of safety pins was suspended from the brim (Arnoldi and Kraemer 1995:45 citing Brown 1944). For some public occasions the hat would be smeared with camwood powder mixed with oil.

PLATE 23. Man's Robe (Riga)

Hausa people, Nigeria, 20th Century
Embroidered cotton, silk
W: 138.4 cm (54 1/2 in.)
Indianapolis Museum of Art
Eugene Beesly Fund
IMA1982.152
Photograph © Indianapolis Museum of Art

A gown such as this is part of an entire ensemble that would be worn only by those with enough wealth and power to afford such intricate work, the result of many hours of intense hand-labor. Part of a man's ensemble, the gown would be worn over embroidered trousers, a long-sleeved shirt, and the outfit would be completed with richly embellished leather slippers or boots, and a cap or turban. The gown hangs over the other clothing and is so wide that the wearer folds the edges in towards the shoulders. Creating such a gown involves the work of many specialists. Strips of cloth are hand-woven by men on narrow looms and then dyed with indigo to achieve the deep blue color. Women spin cotton and silk into thread for the cloth construction and the embroidery. The designs are often drawn on the cloth by a male specialist before the embroiderer takes over. Embroidery is a male art form, done primarily in the urban areas of Northern Nigeria, where this gown is from. Such gowns can take months of intense labor to finish (Heathcote 1972). This robe, said to be from the Hausa, is of a style shared by the Hausa, Nupe, and northern Yoruba, and, as Kriger notes, "their most important feature was their use by Muslim elite, regardless of ethnic affiliation" (1988:52).

Some such elaborately embroidered gowns are made for sale in markets, but as Perani and Wolff point out,

> Aristocrats are more likely to commission them from the embroiderers or to deal with traders who approach them directly with clothing of the highest quality. They [aristocracy from the city of Kano] particularly admire the quality

PLATE 24

of Nupe embroidery, and some of their most prized gowns are obtained by sending messengers to commission embroiderers in the Nupe city of Bida, 480 kilometers south of Kano (19192:73).

The gowns are carefully kept by generations of elite families and have also been distributed by the wealthy as gifts at events such as the installation of emirs (or leaders). The most elaborate gowns are worn for important religious and political events. Perani and Wolff note that in Kano the "District Head appeared in robes of deep blues and reds when receiving important visitors, when attending installation ceremonies for emirs and important officials, and when taking part in the equestrian processions that accompanied the Sallah celebrations marking the end of Ramadan, the Muslim month of fasting" (ibid:72).

The principal embroidery motif on the gown is the eight knives design (aska takwas), named for the elongated triangles pointing downward. Two spirals, one on the front and one on the back, also ornament the gown. The other embroidered elements are variations on magic squares and wisemans' knots, part of the visual vocabulary used in many artforms such as house decoration and leather working, and intended to have protective qualities throughout Islamic Africa.

PLATE 24. Door for Palace Interior (Ilekun Afin), 1930-1950

Oshamuko of Osi, Yoruba people, Ekiti area, Nigeria
Wood, Pigment, Steel
H x W x D: 102.6 x 65 x 7.6 cm (40.4 x 25.6 x 3 in.)
Indianapolis Museum of Art
Gift of the Alliance of the Indianapolis Museum of Art with funds from the Roger G. Wolcott Fund and Mr. and Mrs. Theodore P. Van Vorhees Art Fund
IMA2001.170
Photograph © Indianapolis Museum of Art

By the 11th century AD the Yoruba people (now of southwestern Nigeria and southeastern Benin) were ruled from a thriving metropolis, Ile-Ife, a place where all other Yoruba city-states claim descent. The urban nature of Yoruba civilization makes it unique among African peoples, and at the head of each city-state is the king who rules with divine authority.

The king dwells in the afin, the royal palace. The most imposing architectural structure in a Yoruba city, the afin is also the site of the most sacred worship and celebrations. As in early Ife, the palace stands in the center of the city, and all roads lead to it. The king's market, usually the most important market in town lies at its door. An afin consists of numerous courtyards of varying sizes, most of them surrounded by verandas. Steep roofs, once thatched, are today covered by corrugated steel. At least one especially large courtyard serves as a gathering place for citizens during public rites.

Artists are kept busy fashioning wonderful objects that enhance the splendor of the palace, record the exploits of the kings and chiefs, and display religious symbols and metaphors to the public. In making such commissions, kings historically sought the most skillful artists from their own realms and beyond. The best artists achieved the title ari, which literally means "itinerant," suggesting that they moved from kingdom to kingdom accepting work from a number of patrons (Poyner 2001:240).

This small door was originally from an interior court of the palace of the king of Otun (whose title was the Ore of Otun). William Fagg photographed the door, carved by Osamuko of Osi-Ilorin, in its original context (1982:24, fig. 24). Osamuko is closely associated with some of the greatest wood carvers of the northwestern Yoruba area of Ekiti. He was an apprentice to Ajijola and then was an assistant to Areogun. Osamuko taught Areogun's son Bandele, who taught one of the greatest living Yoruba sculptors, Lamidi Fakeye (Picton 1994:8).

There is no overall narrative that is intended in the door's three registers of low relief carving. Instead, the scenes depict themes and emblematic representations of aspects of life during a time of great change at the beginning of the 20th century. The bottom register shows a priest of Osanyin, the herbalist deity, in the center with two mothers (with children on their backs) offering a bowl and a chicken. A musician blowing a side-blown trumpet and one playing a flute flank them. The middle register depicts scenes emblematic of a 19th century war when the area was brought under the control of Ilorin, the Islamic emirate to the northwest. In this register the central figure is a Muslim warrior on horseback. A prisoner floats above his head, a woman and a child are to the left, and two figures, one holding Islamic prayer beads and the other playing a side-blown horn, are to the right. In the top register a pipe smoking cyclist is the central and largest figure. A seated figure and a drummer are behind the cyclist. A captive carrying a box goes in front, chained to an armed guard seated on the front fender of the bicycle. The cyclist is the British district officer making his rounds (Bourgeois 2001).

Picton notes that both Osamuko and Areogun frequently used pipe smoking figures as an allusion to Eshu the trickster diety, and wonders if what was intended was "an intentionally subversive ridiculing of those agents of a novel but alien authority, a questioning of a questionable legitimacy" (Picton 1948:27-8). ∎

Death and the Ancestors

The objects in this section exemplify some of the diverse attitudes concerning death in Africa, and show how artforms are utilized in the various stages of death rituals. In Africa death is not seen with such finality as in the West. It is viewed as a time of transition where the deceased make their way from the world of the living to the world of the spirits. Death is not usually considered a natural occurrence, unless the deceased was very old. Consequently Africans are concerned to discover the cause of death before burial can take place. Sometimes death was thought to be caused by spiritual powers, unleashed on oneself as the result of breaking taboos or rules, or by another through spells or witchcraft. Death is often unexpected, interrupting families' lives and schedules. The actual burial is usually done soon after death but without accompanying rituals. Instead the funeral proper is held months or even years later. Arrangements can then be made to contact all who should attend, and resources collected so that sufficient food and drink and whatever else is needed is at hand for an appropriate funeral.

Depending on the beliefs of particular societies, not all who die are considered able to become ancestors. Children may be accorded minimal funerals as their spirits can easily be reborn. For those with many descendants and who have achieved high status, a proper funeral assures their attainment of ancestor status. Ancestral spirits are usually considered benign and concerned about the welfare of their descendants. They want to ensure their descendants are prosperous, healthy and multiply sufficiently to continue the lineage. The ancestors, however, can also become annoyed because of misdeeds by their descendants or lack of attention being paid to them, and so may cause problems. Conversely, the living can also appeal to the ancestors to intercede on their behalf.

Mourning is expressed in various ways from loud lamentations to ritual isolation and strictures imposed on daily activities. Among the Akan-speaking people of Ghana wearing dark reds and browns, such as in the *adinkra* cloth, is the recognized symbol of mourning. Some artforms deal with the perception that the dead are considered to be potentially dangerous in the period between burial and the formal funeral. Dogon masks urge the deceased's spirit to leave the world of the living and continue on to the realm of the ancestors. The Senufo *kponyungo* mask likewise fights against antisocial forces trying to prevent the dead from becoming an ancestor. The chameleon seen on the *kponyungo* mask, with its ability to transform in color, is an apt metaphor for the intended transformation of the deceased to an ancestor. Throughout Africa the more lavish the funeral, such as exemplified by the Bamileke elephant masquerades, the greater the status accorded the deceased and their descendants. Among the Mijikenda peoples of Kenya it is only the high status Gohu society members who have funerary commemorative posts made for them. In some areas sculpture is created to protect the reliquaries of the dead, such as among the Kota. In other areas memorial sculptures are made to honor the deceased. Portraiture is usually done in a more stylized way with emblems of rank, status, or occupation being emphasized rather than physical likeness. In many societies an important part of the funerary rituals is inheritance ceremonies. For the Shona of Zimbabwe inherited utensils of everyday life become heirlooms through which to address prayers to the ancestors. Beer-pots become conduits of spiritual communication for the Zulu because their black color is associated with the ancestors and beer is the favorite food of and offering to the ancestors. ▮

PLATE 25

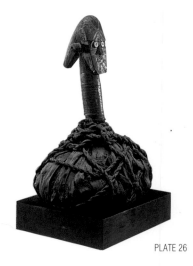

PLATE 26

PLATE 25. Mourning Body Wrapper Textile (Adinkra kobene)

Akan peoples, Asante group, Ghana, 20th century
Cotton cloth, dye
Detail, overall H x W: 264.1 x 345.4 cm (104 x 136 in.)
New Orleans Museum of Art
Gift of Mr. and Mrs. John E. Anderson
90.145
Photograph by Judy Cooper
Photograph © New Orleans Museum of Art

Adinkra cloth is one of the best known types of Ghanaian cloth. The Akan people wear cloth of somber colors such as black, dark brown or brick red when they are in mourning. The brick red color is known as *kobene* and when the cloth of this color is stamped with motifs, as is this example, it is known as *adinkra kobene*. It is the color, therefore, that makes it a funerary cloth. It is often assumed that all *adinkra* cloth is mourning cloth but some *adinkra* is made on bright or white backgrounds. It is known as "fancy *adinkra*," and is more appropriately worn for festive occasions (Cole and Ross 1977:44-47). The origin of the name *adinkra* is unclear. *Adinkra* is sometimes said by the Asante to have been borrowed from the Gyaman, a small defeated group to the northwest who had chiefs named Adinngra and Adinkra. Another interpretation "glosses *adinkra* to mean "to be separated" or "to leave" or "to say goodbye" (from *di*, "employ," and *nkra*, "message left on departing"), an interpretation that strongly supports the mourning function" (Cole 2001:208). Several other west African people, including the Bamana and Senufo, also make cloth with linear painted patterns that has protective functions (albeit using different techniques and with very different appearances). The possibility that they, along with *adinkra*, are all part of a complex of cloth influenced by Islamic ideas such as magic square inscriptions is strong (Cole ibid.).

The cloth, usually European produced cotton yardage, is first dyed to the appropriate color and then pegged out on a flat surface. A dye is made from tree bark and iron ore or slag, and the resulting black glossy tar-like liquid is applied with stamps and combs to the fabric. The combs are used for drawing the parallel lines making up the grid-like squares and rectangles. Within these grids a stamp of a particular design is then repeatedly impressed into rows. The stamps are carved by wood carvers of calabash and fitted with short handles. There are more than two hundred different *adinkra* designs (not all still being used) ranging from abstract designs to representations of things from the natural world. As was explained with Akan goldweights, these symbols are linked to proverbs or

verbal maxims which have varying interpretations. A simple search on the Internet produces almost 5,000 sites with content about *adinkra* symbols. A brief look at some shows that *adrinka* cloth has become almost as potent a symbol of African American pride as kente cloth. The motif on this cloth is "Musuyide, [meaning] 'something to remove evil,' and probably [is] based on an Islamic charm shape" (Cole 2001:207). Another commonly used symbol is Nyame dua or Gye Nyame which is interpreted as symbolizing God's greatness or omnipotence for the saying means "except God" and means I fear nothing except God.

PLATE 26. Reliquary figure with tied bundle (Nbumba bwiti)

Kota-Ondoumbo or Sango peoples, Gabon, 19th- early 20th century
Wood, brass, copper, shell, rope, natural fiber
H x W x D: 32.4 x 19.4 x 16.5 cm (12 3/4 x 7 5/8 x 6 1/2 in.)
New Orleans Museum of Art
Bequest of Victor K. Kiam
77.234
Photograph by Judy Cooper
Photograph © New Orleans Museum of Art

Several of the peoples who live in the dense rain forests of Gabon, Equatorial Guinea and southern Cameroon venerated the relics of their ancestors. They kept them in basket or box containers, or as in this case, tied and bound in bundles. Family chiefs, judges, religious specialists, artists, and especially fertile prolific mothers all received this honor on their deaths. Although no longer practiced today, the skull and certain other bones of important relatives were previously kept in these reliquaries and guarded by figures called (depending on the area) *bwiti* (or *bwete*), *byeri*, or *mbulu*. While the guardian figures by themselves are relatively common in museums and private collections, (missionary and indigenous witch–hunting activities in the 1920s caused many to be sold to Europeans). Examples of reliquary bundles and guardian figures still together are rare. Because it is the relics rather than the guardian figures that were expected to protect and benefit the families who owned them (Siroto 1968), it is not surprising that the figures would be sold but not the bundles. There are many styles of reliquary figures, some figurative and some highly abstracted. Those of the Kota and their neighbors, however, with their overlays of copper and brass strips and sheeting are among the most distinctive. This figure, with an oval head, circular staring eyes and metal strips ringing the neck, has been identified as being from the

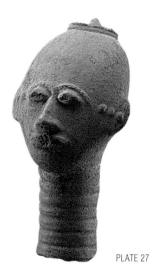

PLATE 27

Kota-Ondoumbo or Sango peoples of central Gabon. The bundle and figure together are known as *nbumba bwiti* (Chaffin and Chaffin 1979; Perrois 1985). X-ray examination of this bundle by the New Orleans Museum of Art proved inconclusive. There was little in the way of identifiable bones that could be recognized and there were only remnants of what perhaps were originally European metal buttons or badges, surely once-prized possessions of the deceased.

The copper and brass sheathing covering the carved wooden guardian figure is a most striking feature. Figures were periodically washed and shined to enhance their ability to ward off any forces trying to interfere with the power of the relics. The brass was itself a symbol of wealth and status, for it was used as currency, and came into the area through European trade. Brass wire and brass basins (known as neptunes) were the two most important commercial forms of brass, and the sheeting and strips ornamenting the guardian figures were hammered and cut from these sources. The reliquaries and their protective figures were usually kept in lineage shrines but the figures were occasionally removed from their bundles and brought together for a public performance. This occured when it was necessary to combat community-wide evil such as death of the leader, an epidemic, or if all the village were embarking on a communal hunt (Siroto ibid).

PLATE 27. Royal Male Memorial Head

Akan peoples, Asante group?, Ghana, 19th- early 20th century
Terracotta
H x W x D: 27.3 x 14 x 13.3 cm (10 3/4 x 5 1/2 x 5 1/4 in.)
New Orleans Museum of Art
Bequest of Victor K. Kiam
77.105
Photograph by Judy Cooper
Photograph © New Orleans Museum of Art

Ceramic figural sculpture has been made to commemorate the dead among Akan speaking peoples of southern Ghana and southeastern Côte d'Ivoire (Ivory Coast) for centuries. Examples are found in archaeological contexts (see Bellis 1982), and from the 17th century on, European travelers to the area reported the use of such terracotta memorial sculpture. Pottery vessels with relief decorations were primarily made for ordinary people, while terracotta figurative sculpture, such as this example, probably broken from a full figure, were reserved for the royalty, including chiefs and queen mothers. The figures and heads were made for funeral celebrations, which for the Akan, as for many Africans, occur not at the time of burial of the body, but months and sometimes years after the death of a person. The terracotta images were at times displayed on royal chairs, adorned with cloth and then paraded to a location, separate from the cemetery, known as the "place of pots." The figures were surrounded by smaller ceramic figures to represent the deceased's spouses, their entourage, and officials during life, therefore symbolizing the wealth and status of the chieftancy. Rituals were performed with offerings of food, drink, and prayers at this "place of pots" as the community said their final good-byes (McLeod 1981:157-161, Cole and Ross 1977:117-127).

Women were the primary artists of these sculptures, just as they are the potters of Akan society. In some areas the artists reportedly looked into a bowl of water or palm-oil to visualize the features of the deceased (Sieber 1972). The figures are considered by the Akan to be portraits of the dead, but not in the Western sense of a physical resemblance. Among the Akan (as is the case in most African sculpture), age, blemishes, and most personal physical features are not depicted in portraiture. Instead specific hairstyles, scarification and emblems of rank and status are used to represent a person using Akan idealized aesthetic stylizations. Preston notes that at "the beginning of this century, it was the fashion for male elders at the courts of paramount chiefs to trim their hair into figured patterns and to shave the remainder of the scalp" (1981:81). Perhaps this is what the circular ornamentation on the back of this head represents, and, because there are no pierced lobes for earrings (seen on female heads), the head represents a royal male. Terracotta heads, such as this one, are often assumed to be from the Asante, the best known Akan group. According to Ross, the majority of these ceramics are from the southern Akan areas (1995:438). Annual rituals and commemorations were sometimes done at the "place of pots" but in other areas the figures were simply abandoned after the initial rituals. In some areas the use of these figures for funerary purposes continued until the 1970s. Gilbert (1989) cautions that such funerary practices were not uniformly followed throughout the Akan areas because in some areas the terracotta figures represented deities rather than ancestors.

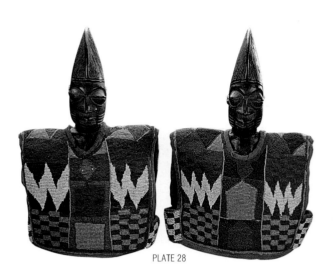

PLATE 28

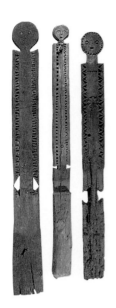

PLATE 29

PLATE 28. Twin figures with beaded gowns (Ewu Ileke Ibeji)

Yoruba peoples, Nigeria, 20th century
Wood, fabric, glass beads, string, metal, pigment
H (of taller): 36 cm (14 3/16 in.)
UCLA Fowler Museum of Cultural History
Gift in memory of Barbara Jean Jacoby
FMCH X86.1085 a-d
Photo by Don Cole
Photograph © UCLA Fowler Museum of Cultural History

Children are a joy to parents throughout the world. When they die parents mourn their loss. Among the Yoruba-speaking people of southwestern Nigeria and southeastern Benin the birth of twins is a joyful occasion for it is felt twins will bring good luck to their families. Unfortunately twins are often born prematurely, underweight and with a higher likelihood of mortality. The Yoruba believe that twins share a soul and so when one twin dies, the dead twin will beckon for its soul-mate to join it. Parents obviously do not want this to happen and so will approach a diviner for guidance. They will be told to have a woodcarver make an image of the twin who died (such as these examples) and care for it as they would the living twin. That way the dead twin will not feel jealous or neglected. Demographic studies reveal that the Yoruba have one of the highest incidence rates of twin births in the world, and so it is not surprising that over the centuries tens of thousands of twin figures (ere ibeji) have been carved and used (Houlberg 1973).

The figures are carved to represent the child, not as a baby, but, as is the pattern throughout most of Africa, as an adult in the prime of life. Carvers adhere to regional and local stylistic preferences and so two *ibeji* of the same carver or workshop will often look the same even if not originally a pair. Mothers of twins lavish attention on the figures: "they are oiled, rubbed, washed, dressed, fed, danced, sung to, rocked to sleep and awakened in the morning, and decorated with expensive jewelry, money and beads" (Drewal 1998:248). The worn facial features are often evidence of the attention paid by mothers to these small figures over many years. The care of the figures often continues for generations, with the surviving twin taking over as parents die, and succeeding female family members caring for the figures later. Beads are the prerogative of Yoruba royalty and so these twins may have been of royal blood, or they are associated with the deity of thunder and lightning, Shango, whose priests wear similar beaded gowns. Drewal notes "this pair of memorial figures. As well as their beaded cloaks, were created by the same artist. The tripartite composition of the garments may be a symbolic reference to twins followed by the next

child who would be called *Idowu, Eshu l'ehin ibeji* (Idowu, the Eshu [trickster deity] that follows twins)" (Drewal ibid. 252).

PLATE 29. Commemorative Posts (Vigango)

Giriama and Chonyi Peoples, Mijikenda Complex, Kenya
Wood
H: 173.4, 171.5, 191 1 cm (68 1/4, 67 1/2 and 75 1/4 in.) (overall)
Indianapolis Museum of Art
Gift of Edgar Gross
IMA1987.277; IMA1987.275; IMA1987. 273
Photograph © Indianapolis Museum of Art

These figures are commonly misinterpreted as grave markers, but these imposing vertical sculptures are neither made to be placed on graves, nor are they erected at the time of the burial of the men they were made for. They are known as *vigango* (singular *kigango*) and are erected to commemorate deceased members of the Gohu society from the Mijikenda peoples of southeastern Kenya. The Gohu society is a group of elderly men who previously had a role in regulating matters between the sexes (in cooperation with a parallel society of women), and is now primarily known for their conspicuous consumption, lavish parties and for their generosity (Parkin in Wolfe 1986). Some years after a Gohu member dies, one of the man's descendants will receive instructions by way of dreams to erect a *kigango* because the deceased's spirit wants to be honored. A carver is then commissioned to carve the *kigango* from a termite-resistant wood, and living Gohu members participate in a ritual to erect it at the family's home. These ornately ornamented posts were meant to mirror the status the Gohu member achieved while he was alive but this veneration was not always enduring. The posts could be moved once if the family relocated but were then abandoned if the family moved again (Wolfe 1986).

Roy Sieber notes that these sculptures fit into a broader tradition of commemorative and grave sculpture seen in eastern Africa and has suggests that the posts may owe part of their inspiration (especially the non-figurative geometric chip-carved motifs) to their neighbors, the Swahili (in Wolfe 1986). Evidence of compasses and ruler use in designing the posts (not a typical African technique), is probably due to Swahili influence. Three-dimensional heads on the *vigango* seem to coexist with the flat more abstract heads (seen on these examples) so it is difficult to establish if one type necessarily preceded the other. The linear and circular motifs hint at body parts such as arms, waists, shoulders, and navels but none are overtly depicted.

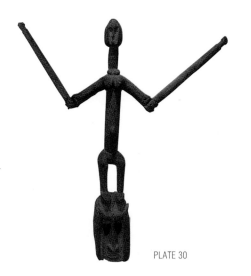

PLATE 30

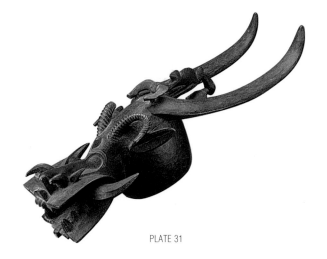

PLATE 31

PLATE 30. Face Mask with female figure (Satimbe)

Dogon people, Mali, early 20th century
Wood and rawhide
H x W x D: 97.2 x 87 x 10.5 cm (38 1/4 x 34 1/4 x 4 1/8 in.)
New Orleans Museum of Art
Bequest of Victor K. Kiam
77.148
Photograph by Judy Cooper
Photograph © New Orleans Museum of Art

The Dogon people of Mali stage elaborate funerary celebrations to commemorate and honor those who have departed, and to ensure that their spirits leave the world of the living and go to their properly appointed realm of the dead. These celebrations, known as Dama, happen years after the deceased have been buried. The time lapse is necessary because enough resources must be accumulated to stage the celebrations. Distant relatives must be notified and enough masquerades prepared to properly honor those who have died since the last Dama. When boys are initiated into the Awa, or men's masking association, they make their own Kanaga mask. It is the most common Dogon mask, has the same rectilinear features seen on the face of this mask, and is surmounted by a four-part cross of flat board-like segments. Professional blacksmith/carvers make the scores of other mask types that appear at the funerary Dama celebrations. There are other fiber masks depicting non-Dogon women, but this mask, known as Satimbe, is the only wooden mask to depict and honor Dogon women. "The mask represents not only the *Yasigine* ('sister of the *sigui*'), but also all subsequent women who are *Yasigine*. Women become *Yasigine* if they are born during the *sigui* ceremony [occurs every sixty years] and display unusual social behavior, or if they demonstrate spirit possession, regardless of whether or not they were born during *sigui*" (Roy 1992:35 citing personal communication with Pascal Imperato).

The French anthropologist Marcel Griaule sheds light on some of the complex cosmological underpinnings of Dogon philosophy in his classic study of their religion, *Conversations with Oguntemmêli*. It is based on a series of conversations Griaule had in 1946 with the blind former hunter cum Dogon intellectual, Oguntemmêli. Concerning the coming of death to the world, Oguntemmêli recounted how an old man

> having reached the term of his human life, had, like the ancients, been changed into a Nummo Spirit; but, in accordance with the rule, he had not gone up to heaven and had continued his earthly life in the form of a great serpent. One day when the young men had dressed themselves in their fibres [all

masqueraders still wear a skirt of these fibres], which they kept hidden in caves, and were on their way to the village, the spirit met them and barred their way. Angry at having been flouted [the men had not told him they had stolen the fibres from women], he violently reproached them. speaking in the Dogon language so they could understand; and this was the cause of his death....By speaking to the men in a language that was familiar to them, he was transgressing a prohibition, and cutting himself off from the superhuman world, in which he was now an impure element, and so could no longer live there. It was equally impossible for him to return to the world of men. Accordingly he died there and then (Griaule 1970:170).

PLATE 31. Mask, (Kponyungo)

Senufo people, Côte d'Ivoire (Ivory Coast), mid 19th century/ mid 20th century
Wood, pigment
H x W x D: 27.9 x 27.3 x 102.9 cm (11 x 10 3/4 x 40 1/2 in)
The Art Institute of Chicago
African and Amerindian Art Purchase Fund
1963.842
Photograph by Robert Hashimoto
Photograph © The Art Institute of Chicago

This spectacularly ferocious–looking mask is made by the Senufo people of northern Côte d'Ivoire (Ivory Coast). It is best known as a funeral mask for the most senior of Poro association members. There are, however, non-Poro men's associations who also use the masquerade to combat against anti-social forces such as witchcraft, malevolent bush spirits, or the wandering dead trying to disrupt the community. The mask's name, Kponyungo, has been translated to mean "funeral head mask" (Glaze 1988:215) but as Förster points out (1988) this name is mostly used by the woodcarvers to designate the part of the masquerade they manufacture. The rest of the ensemble consists of a pair of cloth trousers and shirt dyed with reddish brown geometric and figurative patterns, and the masquerader always carries and plays a double-headed drum. One of the mask's nicknames is *yakaha*, meaning "mouth open" (Glaze ibid.), and the ravenous nature of this beast certainly is emphasized. The composite creature is made up of hyena mouth, crocodile teeth and six pairs of horns and tusks from a variety of animals including rams and creatures of the bush. Kponyungu masks often have antelope horns extending above, but here, as the horns are flattened and without striations, it is the dangerous buffalo that is represented (Förster ibid.). A hornbill and a chameleon complete the bestiary collection. The chameleon and the hornbill, among the most important of Senufo symbols, were both present at creation and stand for primordial knowledge and transformational abilities.

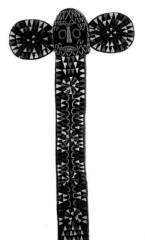

PLATE 32

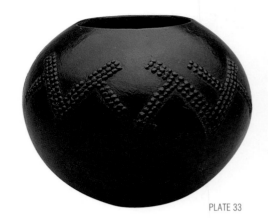

PLATE 33

The Poro society is the principal male organization through which Senufo males are socialized. Groups of young men are initiated together as an age group, and pass through a series of phases lasting up to twenty years as they learn and put into practice their social, political, and religious duties in the community. This mask is associated with the most senior grade of Poro, Tyologo. It takes seven years to graduate from this final phase when men are in their mid-thirties (Glaze 1988:144). It is for the funerals of these most respected Poro members and their wives, that the Kponyungo masquerade is performed. Glaze points out,

the funeral is the final rite of passage, one that transforms the dead into a state of being that is beneficial to the living community, thereby ensuring a sense of continuity between the living and the dead. Only in the "village of the dead" can one function effectively and safely as an ancestor, a mediator between the human and the supernatural. Left angry or dissatisfied with relatives and the home village, the dead one remains a dangerous threat to all succeeding generations (1981:149).

PLATE 32. Elephant mask (Mbap Mteng)

Bamileke peoples, Cameroon, 20th century
Cloth, glass beads, plant fiber, dye, metal
Dimensions H x W x D: 120 x 66 x 20 cm (47 1/4 x 26 x 7 7/8 in.)
The Field Museum, Chicago
174142
Photograph by Diane Alexander White
Negative #A114184 3c

The beaded arts of the Cameroon grasslands plateau area are typically characterized by the brilliant juxtaposition of patterns, colors and forms seen on this elephant mask of the Bamileke people. Although there are human features of eyes, ears, and nose on the face of the mask, the long rectangular cloth panel hanging below the face represents the elephant's trunk, and the circular disk-like appendages on either side of the face are the elephant's ears. The name of the mask, *mbap mteng*, means "animal with large ears." The multicolored beaded triangles covering the mask, however, represent the spots of a leopard, and so two powerful animals are symbolically represented. Notue reports that the elephant mask "symbolizes power, authority, prestige and leadership. It is believed that the *fon* (king) and some prominent initiate notables may at will turn into elephants and leopards, thanks to *ke* (transcendental and dynamic power, occult and fertile force, magic)" (2000:113).

The entire ensemble costume of the elephant mask consisted of such things as tunics, beaded vests, and horsetail fly wisks and for those of higher rank and status, leopard pelts. The mask performed at annual celebrations of the elephant societies and especially the funerals of chiefs and members of those societies. While the king, or *fon*, is at the apex of Bamileke society, notables organized into secret societies, balance his power. Geary notes that,

A sketchy picture emerges of elephant masks being associated with men's societies found in most Bamileke chiefdoms: the Kuosi, Nekang, and Kemndze. These societies were initially warrior societies with regulatory character, which might explain the use of the elephant as a fitting metaphor. Over time they changed into prestige societies, assembling wealthy, titled men who pay for the privilege of being inducted, and pay further to advance within the group....Their elephant masks articulated the multiple functions of these societies in form and media, for they embodied the major ideological premises on which the chiefdoms—and with it the two types of societies—were founded. One was the constancy of warfare, that is the exertion of power and authority over an ever increasing number of people brought into the chiefdoms by force; the second was the accumulation of wealth to advance in rank (1992:246, 253).

PLATE 33. Beer Container (Ukhamba)

Northern Nguni (probably Zulu) peoples, 1940/1950
Terracotta
H x Dia.: 22.5 x 27.9 x cm (8 7/8 x 11 in)
The Art Institute of Chicago
African and Amerindian Art Purchase Fund
1994.316
Photograph by Robert Hashimoto
Photograph © The Art Institute of Chicago

Elegant, circular, symmetrical, rimless, and neck-less pots such as this, are probably the best known and most easily identifiable pots of the Zulu and their Nguni neighbors. Women (who are the potters in most of Africa) make them using the coil method to build up the pot walls, and fire them, without any kiln, using sticks and dried cow dung for fuel. These type of pots are fired a second time to produce their black color. This second time is known as a reduction firing, a technique used in many parts of the world where too much fuel in a firing environment with too little oxygen, causes deposits of carbon to go onto, and right into, the clay body. When cool, animal fat and plant leaves are rubbed onto the surface of the pot with a pebble to achieve the characteristic shiny black surface (Bryant 1948:400).

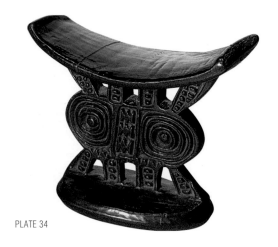

PLATE 34

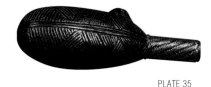

PLATE 35

What do these refined utilitarian vessels have to do with death and the ancestors? These vessels, known as *ukhamba*, are for serving and drinking home-brewed sorghum beer, and the black color of the pots, which no other type of pot is given, is associated with the ancestors. Beer was once the enticement for communal work parties and was featured at a host of other community events. With the 20th century movement of many people to urban jobs, most beer drinking is now done in municipal beer-halls or shabeens (illegal drinking establishments). Yet there is a marked persistence in using the sorghum beer for rituals when people routinely return to their rural homes. The beer is considered the favorite food of the ancestors and is the key to communication with them. When beer is first brewed it is placed at the *umsamo*, the sacred area at the back of houses that is dark or black and associated with the ancestors. Beer is an essential component of various transition (or change-of-life) ceremonies where the participation and blessing of the ancestors is essential. These include: introduction ceremonies at birth; coming of age (or now more commonly twenty first birthday parties); marriages; reconciliation ceremonies; and the sequence of rituals at death, including the burial, removal of mourning clothes, and later installation of the deceased as an ancestor (de Hass 1998, Reusch 1998).

This fine old example of an *ukhamba* features an ornamentation of raised pellet-like protuberances known as *amusumpa*, or warts. They are arranged into criss-crossing bands around the center of the pot. Klopper has noted that this ornamentation design is also found on headrests, meat-trays and other Zulu artifacts. Although the motif was first used in the area where the Zulu kings lived, it also became associated more broadly with royal patronage and power (rather than being restricted to a particular ethnic group or geographical area) and has now spread to neighbors (1991:85-86).

The clustered studs are a reference to wealth in cattle, which were central not only to Nguni cosmology and to the relations between men and their ancestors, but also the chief form of bride-wealth. This makes it unsurprising that the pattern was produced not only *by* women but *on* them: early photographs show that it was customary to beautify both wives and unmarried girls by cicatrising the belly, midriff, chest or upper arms in the various configurations....In latter years *amusumpa* possibly came to represent some aspect (not necessarily a head-count) of the groom's cattle that to this day precedes every traditionalist Zulu-speaker's wedding (Papini 1995:221).

PLATE 34. Headrest (Mutsago)

Shona, Zimbabwe, late 19th – early 20th century
Wood and copper alloy wire
H x W x D: 12.5 x 14.5 x 5.5 cm (5 x 5 3/4 x 2 1/4 in.)
Private collection
Photograph by Lindsay Kromer

PLATE 35. Snuff container (Nhekwe)

Shona, Zimbabwe, late 19th – early 20th century
Wood and copper alloy wire
H x W x D: 13 x 5 x 3.5 cm (5 1/8 x 2 x 1 3/8 in.)
Private collection
Photograph by Lindsay Kromer

These wooden utilitarian implements, a pillow and a bottle for snuff, have lost their previous function for the Shona people and instead are now primarily symbols of the ancestors. Headrests, among the most widely collected art forms of the peoples of southeastern Africa, were originally used to sleep on and for protecting coiffures. At the turn of the 21st century very few headrests are still being used, and even fewer being made. Their primary functions in this part of Africa now revolve around religious usage and serving as family heirlooms. Personal items, if not buried with the deceased (Magava 1973, Mahachi 1987), are divided among descendants at an inheritance ceremony. Such inherited personal items are frequently used as foci through which to direct prayers to the ancestors. The other category of current headrest-users are spirit-mediums. I visited one who had been directed by his possessing ancestral spirit to retrieve a headrest from the cave/grave where the spirit had been buried. As he often displayed the headrest while consulting patients, he used it, in part, as an authenticating symbol to assert the legitimacy of his spirit mediumship. Other spirit-mediums (and one chief) told me that they slept on headrests in order to facilitate having dreams where the ancestors would communicate with them. (See also Nettleton's 1990, "'Dream Machines': Southern African Headrests.")

Shona headrests are only used by men, but the symbolism depicted on the headrests is decidedly female. Headrests are anthropomorphized and genderized, but in a very abstract way. The two features making them female are the v-shaped motifs on the base—identified as the female groin—and the chip-carved surface decorations—identified as *nyora* or female cicatrix (men do not

have them). Just as there is a division of the sexes for roles and occupations (e.g. women are potters and men are blacksmith/ carvers) so there is a symbolic genderized division of many objects and division of who may appropriately use them. In polygamous households, husbands used their headrests to indicate which wives they were going to sleep with by placing them outside the wife's houses. As one elderly women told me, in the typical understated and at times veiled prose of the Shona, "if you saw the headrest, you would know you were going to have a guest that night" (Dewey 1993:101).

Snuff containers are frequently handed down from generation to generation and are often associated with the ancestors in a very personal way. Snuff also has several uses in Shona society besides as a pleasuable habit. The use of snuff, for example, is important as a sign of reconciliation between two disputing parties. This use is further emphasised by the Shona saying *kusvutidzana fodya*, which translated literally means "to cause to take snuff together," but its idiomatic meaning is "to be reconciled" (Hannan 1981:626). There are two classes of religious/medical specialists who use snuff. The first, *n'angas* or diviner-herbalists often prescribe snuff to be for various ailments. The second category of religious/medical specialist, *svikiro* or spirit-mediums also use snuff. Some, especially those who are not as experienced, must participate in long ceremonies of music and dancing in order to induce possession. In others, possession can be induced by simply clapping a greeting or giving them a little snuff.

The most important ritual use of snuff is as an offering to the ancestors. After the death of the male head of a household, it is believed that his spirit continues to provide protection for his descendants. People often explained that when embarking on a journey snuff should be given as an offering to alert one's ancestors. Favors of all sorts could also be asked of the ancestors, and when they were provided, the ancestors would be thanked with an offering of millet beer or snuff. The pervasiveness of this practice of offering snuff to the ancestors was dramatically illustrated to me in 1984 when I was watching the proceedings of ZANU's (Zimbabwe African National Union, the country's ruling party) Second Party Congress on Zimbabwean television. At the closing ceremonies, with no explanation needed, a ZANU leader performed a simple ceremony at the podium, pouring some snuff out of a snuff bottle onto a leaf. He was obviously thanking the collective ancestors. ▌

Utility and the Art of Living

This section presents a cross-section of arts that are often considered to be utilitarian, including dress, pottery, furniture, containers, weapons, and currency. The artificiality of distinctions between utilitarian and other artforms becomes clear when it is realized that the objects included in this section could just as easily have been placed in the exhibition's other categories. And those in other categories could have been included here. Only recently (the last few hundred years) has the West segregated Art, with a capital "A," from other categories of material culture, and decided it is worthy to be displayed on walls and placed in museums. Historically, Western art was part of religion, government, etc., and was seen in the context of churches and palaces, and worn and displayed by rulers and priests. In Africa, art was, and still largely is, part of everyday lived experience. In the last few decades much discussion and debate has taken place in the West about whether there is a valid distinction between art and craft. Generally craft has been downplayed because it is utilitarian or functional, and perhaps because it has often been created by women. The same can be said for such distinctions in Africa where there is a strict gender differentiation related to what materials can be used by whom. Men work in metals and wood, while women create pottery, certain types of textiles, and baskets. The Western preference for African sculpture and masks has, therefore, meant that women's arts are often ignored. While some African artists are full-time specialists with years of training and apprenticeship, many others, both men and women, are part-time specialists who are subsistence agriculturists or herders who make art in their spare time. These part-time artists also gain reputations of excellence, and their work can be in high demand.

Dress and personal adornment are certainly part of everyday living, and are a means of symbolic communication. Clothing, jewelry, hairstyles, and body decoration are influenced by personal and cultural elements. Multiple concepts of identity, ranging from age, marital status, occupation, and ethnicity can all be conveyed. The Kongo hat and Bura baby bonnet both declare their owners' ethnicity. The Kongo hat also proclaims that the wearer has considerable status and authority, while the wearer of the Bura bonnet is still under the careful protection of its mother. Wooden pillows, such as the Yaka headrest, are a form of furniture but are also used to protect coiffures. Weapons and jewelry exhibit wonderfully inventive variations of form. Some have left the realm of the utilitarian to become symbolic of other things. For example, the Kwele blades are symbolic of value and functioned as currency tokens. The pottery of Abatan demonstrates emphatically that African artists are not anonymous. In her latter years Abatan's renown was such that she only made ritual pottery. Elegant forms are seen in the example of a Tutsi basket, and an Nguni wooden container. The stunning beauty of such objects has helped them make the transition to acceptance in Western culture, where they are often exhibited simply for their sculptural form. ▌

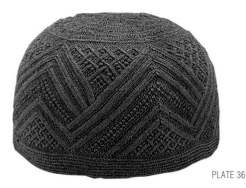

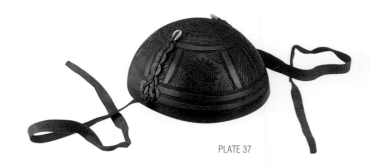

PLATE 36

PLATE 37

PLATE 36. Hat (Mpu)

Kongo peoples, Mayombe region, Democratic Republic of the Congo
(formerly Zaire), early 20th century
Pineapple fiber
H x W x D: 10.2 x 15.2 x 15.2 cm (4 x 6 x 6 in.)
National Museum of African Art, Smithsonian Institution
Museum Purchase
84-6-4
Photograph by Franko Khoury
Photograph © National Museum of African Art, Smithsonian Institution

Hats and caps serve as perfect examples of an artform that has long been overlooked by Western collectors and museums but has been of great importance to African peoples. Kreamer notes that even with everyday headwear,

[w]hether the intention is to offer protection from the elements, to conform to notions of social propriety, or to make individual fashion statements on less formal occasions, daily wear hats function as aesthetic enhancements to everyday lived experience. The care with which everyday hats are constructed, the manner in which they are worn, and the decorative embellishments that make an ordinary hat distinctive—all these factors contribute to the beauty of the hat and the aesthetic experience of the wearer (Kreamer 1995:96).

This hat from the Kongo people is an article of utility, but also makes a political statement as a hat of leaders. The Kongo kingdom, founded in the later part of the 14th century, was, until the kingdom declined in the 18th century, the most powerful political entity in west central Africa. Portuguese who visited the area at the end of the 14th century were impressed with the centralized political system headed by a divine king, who was supported by governors, advisors and village chiefs. They were also in awe of their textile-making abilities. In the 16th century Duarte Pacheco Pereira wrote, "they produce cloth from palm fibers with velvet-like decoration, of such beauty that better ones are not made in Italy. In no other part of Guinea is there a land in which they are able to weave clothes as in the Kongo Kingdom" (as cited in Stepan 2001:26). Much sought after by European visitors, some of these cloths ended up in the curiosity cabinets of European royalty (e.g. that of the Danish kings, which subsequently became part of the Danish National Museum) (ibid.). Another early Portuguese visitor noted that the king wore a mitre-like hat of this velvet-like raffia fiber (Arnoldi and Kraemer 1995:43).

The Kongo kingdom declined in the 18th and 19th centuries, but their legacy and many of the same emblems of leadership are still used by the Kongo-related peoples living in the area. Caps (*mpu*) still

function as insignia of status and authority. The importance of the cap as a symbol of leadership is demonstrated by the Kongo word for village chief, *mfumu* or *mfumu a mpu*, "chief of the cap" (Gibson and McGurk 1977:73). At the lowest level of political hierarchy, the village chief (*nkazi*) is charged with overseeing the village's political, judicial and economic activities. The chief is also seen as an important ritual leader responsible for maintaining proper spiritual relations with the ancestors for the benefit of the village population. The transfer of political office is signaled by the passing of the cap belonging to the late chief to his successor (Arnoldi and Kraemer ibid.)

Constructed of either raffia, or as in this case pineapple fiber, such caps are characterized by their intricate geometric patterns incorporating knots and cut-pile work. The close-fitting hat (or cap) is seen on many wood-carvings of Kongo royal figures, and they are "worn by chiefs at the time of their investiture and by noblewomen who would give birth to future rulers (Williams and Freyer 1999:114).

PLATE 37. Baby bonnet (Dambalam)

Bura peoples, Nigeria, late 20th century
Gourd, leather, cowrie shells, coins
H x W x D: 11.5 x 22.6 x 23.9 cm (4 1/2 x 8 7/8 x 9 7/16 in.)
National Museum of African Art, Smithsonian Institution
Gift of Mildred A. Morton
2000–29-1
Photograph by Franko Khoury
Photograph © National Museum of African Art, Smithsonian Institution

Gourd decoration is one of the most under-appreciated art forms of Africa. Partly because of the fragile nature of gourds, they are rarely seen in private and public collections. Likewise, because most gourds are used for utilitarian purposes as dishes, basins, and containers they have been largely ignored by Westerners interested in "art." As this baby bonnet attests, however, the artistry on utilitarian forms can be quite stunning. Among the Bura of northeastern Nigeria, where this hat is from, gourd decoration is a women's artform. They utilize a technique known as pyro-engraving which involves heating a knife blade over a fire and then scoring and at the same time burning lines into the surface of the gourd. Bura motifs often include the central circular design framed by concentric circles, as in this example, and then the rectangular registers are filled with geometric motifs. The designs have names which sometimes refer to what they look like, or to the way in which they were made, such as for this example, cross-hatching and curves (Rubin 1970, Berns 1985).

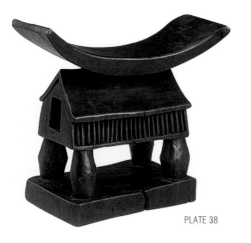

PLATE 38

PLATE 39

Although the individual designs do not have symbolic meaning, the overall design and the objects themselves do visually communicate a message to those who can read them. The overall design is done in a particular style that indicates the ethnic identity of the mother and child. Finely decorated gourd bowls are made in a variety of sizes and are an essential part of marriage ceremonies. The groom's family provides some bowls as bridewealth and the bride's family assembles a large collection as her dowry. The gourds, therefore, symbolize her married status, her aesthetic taste, and her economic status as reflected through the number of gourds she can bring to a marriage (Arnoldi and Kramer 1995:38-39).

African babies are routinely carried on their mothers' backs, and on the high plateaus of northeastern Nigeria the gourd hats, secured with leather straps under their chins, keep the babies out of the sun. Such bonnets are part of a baby's layette and these treasured items are frequently passed down from generation to generation (ibid.). British West Africa coins (from the first half of the 20th century) attached to this example indicate that this family heirloom has served many generations.

PLATE 38. Headrest, (Musawa or Musua)

Yaka People, Democratic Republic of Congo (formerly Zaire),
mid 19th century/early 20th century
Wood
H x W x D: 16.7 x 17.4 x 9.8 cm (6 9/16 x 6 7/8 x 3 7/8 in.)
The Art Institute of Chicago
Gift of George F. Harding
1928.175
Photograph by Robert Hashimoto
Photograph © The Art Institute of Chicago

The Yaka of southwestern Zaire produced a great variety of caryatid headrests, with images ranging from human, leopard, and antelope to this example of a house on stilts (See Bourgeois 1984:70-76). Bourgeois notes that headrests are apparently falling into disuse. The only headrest he saw in a Yaka village in 1976 had been discarded and damaged and was only being used as a plaything by children. Nevertheless, by drawing upon elders' recollections he has been able to provide a wealth of information about their use and symbolism.

[The headrests were] used by traditional male dignitaries but most especially by *kalaamba*, land chiefs and some matrilineal headmen (*lemba*) to support

and protect elaborate headpieces or coiffures. As the headpiece of a *kalaamba* functions as a communal charm, it had to be worn both day and night. [See Bourgeois article "Yaka and Suku Leadership Headgear" 1982]…The neckrest was kept in the bedchamber, an inner room of a pitched 2-room cabin. They appear to have been personal property rather then heirlooms and may have had personal charms attached.

Decision making frequently entailed an elder or diviner "dreaming" on the matter which has implications for this object and its imagery….Neckrests were made by a traditional carver *n-kaleweni* (Kiyeka) who had, in most cases apprenticed under some relative. The item followed the individual artist's style or repertoire of forms. Like in other imagery on masks, faces and figures on neckrests can possibly be read as ancestors/elders manifested in dreams, leopard as a signifier for a person in authority, cabin as the domestic unit, antelope as trickster animal of the forest or savanna. Yet when given carvers were questioned as to the precise meaning of their imagery, uniformly they responded that the imagery was for decoration alone and are traditional forms (personal communication 6/92).

PLATE 39. Currency tokens (Mezong)

Kwele peoples, Gabon and Republic of the Congo,
19th or early 20th century
Iron
H x W x D: 49 x 41 x 3.5 cm (19 5/16 x 16 1/8 x 1 3/8 in.)
Private collection
Photograph by Lindsay Kromer

Precolonial African currency tokens occur in a fascinating array of shapes and sizes (Puccinelli 2000). Although they could serve as practical tools, weapons, or jewelry, their foremost purpose was symbolic rather than utilitarian, for they represented value itself. Value is essentially an arbitrary social construction that is constantly being negotiated. It depends on the trust of both parties involved concerning the "worth" of something. Currencies, such as these elegant sculptural shapes from the Kwele peoples of Gabon and the Republic of the Congo (known as *mezong* or *mandjong*), did not function like coins do in our own society. Instead they are what is called a special-purpose (as opposed to our general-purpose) currency and were often exclusively used for such things as ransoming prisoners of war, or negotiating marriage agreements. The shape is derived from iron tools such as axes and hoes but the tokens are too thin and fragile to be used, and they represent the value of work that could be done with such tools.

[S]uch a blade may stand for the totality of the work performed and the harvest gained, of the cooperation to accomplish the task and the sharing of food

PLATE 40

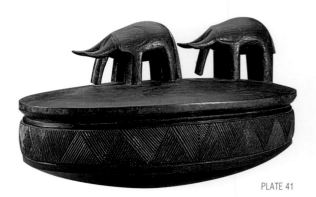

PLATE 41

thereafter, and of land rights and work responsibilities. The value of the iron hoe blade, then, is this totality, that, in many ways constitutes the lifeblood of society itself.

Iron hoe blades were often used as currency tokens in the context of bridewealth, when a groom and his family exchanged wealth for the hand of the bride. Bridewealth was by no means a "purchase," however. Rather, hoe blades given as bridewealth represented an exchange of responsibilities and expectations between the families of the bride and groom. To raise required bridewealth, the groom had to borrow from his kin; in accepting bridewealth, the bride's family redistributed wealth to those from whom they had borrowed in the past. In this way, a woman's bridewealth allowed her brothers to marry, thus furthering their lineage. The exchange of bridewealth cemented these bonds, and was the "glue" of social continuity (Dewey and Roberts 1993:11).

PLATE 40. Basket (Agaseki or Ibeseke)

Tutsi people, Rwanda, 20th century
Grass fibers, dye
H x Dia.: 36.3 x 15 cm (14 5/16 x 5 7/8 in.)
National Museum of Natural History, Smithsonian Institution
Gift of Miss Genia de Galberg
E407783
Photograph by Donald Hurlbert
Photograph © National Museum of Natural History, Smithsonian Institution

The Tutsi people of Rwanda and Burundi make coil-constructed baskets (*agaseki* or *ibeseke*) which constitute some of the most finely constructed and stylistically distinctive basketry forms of Africa. Although some baskets, often of inferior quality, have been produced in recent decades for the tourist market, elegant examples such as this probably date to earlier in the 20th century when such baskets were made by women of the Tutsi aristocracy. They were used for holding foods and personal effects and for presenting gifts. Cuypers hints that there was also a social function for the baskets, for example, when they figured in the exchange of objects in marriage rituals. He speculates that there may also have been a political function to them as they often were produced in the courts of the queen mothers and other notables (1987:44). Further details of such practices need further investigation.

The extremely fine sewing and intricate geometric designs are evidence of the time-consuming artistry and great skill that went into their manufacture. Those baskets made in Burundi have both the cylindrical body of the basket and the conical lid ornamented with patterns. Those made in Rwanda have undecorated lids. The conical covers are known as *umtemeli* and the traditional colors

used to ornament both parts of the baskets were blacks and reds. Carey reports that the red came from the root and seeds of the *ukaramgi* plant and the black from boiled banana flowers or sap. Ndekesi says the black is from soot taken from cooking pots. The motifs which largely consist of various combinations of diamonds, triangles, and zigzags each have names. The zigzags on this basket is like one known as the *umaraza* design (Ndeseki 1986:94-98). Whether there are symbolic meanings associated with the names is unknown.

PLATE 41. Food Bowl (Mukeke)

Lozi people, Zambia, 20th century
Wood
L: 51 cm (20 1/16 in.)
UCLA Fowler Museum of Cultural History
Gift of Helen and Dr. Robert Kuhn
FMCH X91.421a+b
Photo by Dennis Nervig
Photograph © UCLA Fowler Museum of Cultural History

Carved wooden bowls with lids decorated with elephants or water birds are known as *mikeke* (singular *mukeke*), and are the quintessential art objects of the Lozi (previously known as Barotse) people of southwestern Zambia. Because of their elegant shape, finely carved chevron side ornamentation, and especially the stylized figurative elements on top, they are more widely known and collected than any other Lozi objects. Such highly embellished objects were for the elite. For a typical meal two differently shaped bowls would be used—one an open wooden bowl for the *buhobe*, the thick grits-like starchy staple of the Lozi, and the other an oval wooden platter for meat. The *mikeke* were used to hold the stew or relish served with the meal. That this bowl has elephants on top, a royal symbol, may suggest it was intended for serving relish in the royal palace. Previously it was believed that the *mikeke* were made by the Mbunda or Kwangwa people, two of a number of groups incorporated into the Lozi kingdom (Yoshida 1995, 2000). In recent research, however, Karen Milbourne (2002) has clarified this question of ethnicity and placed the production of these bowls into historical context.

Milbourne points out that Lozi ethnicity was largely a constructed notion resulting from Lozi King Lewanika's efforts at the turn of the century to forge a nation of disparate peoples. Lozi ethnicity is therefore a fluid notion and several different people

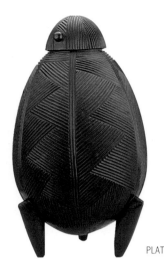

PLATE 42

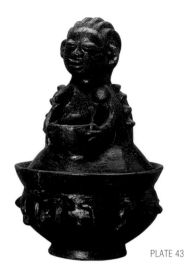

PLATE 43

may have made such bowls before being incorporated into the Lozi nation. Most importantly, she has demonstrated that the figuratively ornamented *mikeke* only started being produced during the reign of Lewanika and that it was but one of his strategies to promote his kingdom to his subjects and the outside world. These were violent times in central Africa requiring ingenuity to survive. Milbourne points out that whereas King Lobengula of the Ndebele, to the south of Lewanika, entered into ultimately futile resistance against the British, Lewanika enlisted European missionary help and was able to avoid war with the British. While he was forced to make concessions, he survived the turbulent times and succeeded in having Barotseland made a British Protectorate rather than a colony.

Lewanika personally promoted woodcarving in the mission schools he encouraged his subjects to attend, and there is strong evidence that he, himself, was an excellent carver. A very similar bowl, now in the American Museum of Natural History, is known to have been carved by Lewanika. To market the crafts of his people, he established a "Native Curio Shop" in the down-river town of Livingstone. Lewanika was clearly catering to the growing number of European visitors coming to Livingstone to see Victoria Falls. Milbourne also shows that the elephant was the most important symbol of King Lewanika. It figured prominently during his coronation, his annual barge journeys (*Kuomboka*) on the Zambezi River, and at his burial. The elephant motif was therefore utilized by King Lewanika as part of his strategy to "broker his own image and that of his kingdom."

PLATE 42. Container (Umbenge)

Northern Nguni peoples, South Africa, probably late 19th century
Wood
H x Dia.: 46 x 28 cm (18 1/8 x 11 in.)
The Art Institute of Chicago
Ada Turnbull Hertle Fund
1979.539
Photograph by Robert Hashimoto
Photograph © The Art Institute of Chicago

This egg-shaped container, delicately balancing on three legs, is clearly a tour-de-force masterpiece of carving, but its intended use is a mystery. The delicate surface ornamentation, with groups of parallel incised lines set in zigzag patterns (reminiscent of plaiting), is also seen on other, more common items in southeast Africa, such as headrests and snuff containers. Similar vessels can be found in

South African collections (see *Art and Ambiguity* 1991:174) and similar vessels, but with deep fluting and more elaborate support structures surrounding them, are in the collections of the Linden Museum, Stuttgart and the British Museum in London (Klopper 1995).

Klopper notes that,

since hardly anything is known about their history or possible functions, it is not even certain that they were produced for an indigenous African market. Indeed most (if not all) of them appear never to have been used as receptacles for liquids or cooked foods, suggesting that they may have been sold as virtuoso examples of African craftsmanship (ibid.)

She also observes that special milkpails for the Zulu kings had lids (unlike the milkpails for the rest of the population). This was to prevent lightning entering, which would preclude the kings from becoming ancestors. Those milkpails, however, are tall, slim, and cylindrical and so the suggestion that the containers like this one were ornate milk containers is, as Klopper points out, an improbable explanation.

PLATE 43. Pot for Eyinle (Erinle) riverine diety (Awo Ota Eyinle)

Abatan Odefunke Ayinke Ija of Oke-Odan (1885-1967)
Yoruba, Egbado people, Nigeria, early 20th century
Ceramic
H x Dia.: 40 x 25.7 cm (15 3/4 x 10 in.)
National Museum of Natural History, Smithsonian Institution
Gift of C. C. Roberts
Base: E380511, Lid: E380513
Photograph by Donald Hurlbert
Photograph © National Museum of Natural History, Smithsonian Institution

A persisting myth is that African artists were anonymous. Thankfully that misconception is changing, and more and more African artists are being identified and receiving their due recognition. The lack of information about African artists (especially of the African art housed in countless museums around the world) stems primarily from the circumstances of the collection of their art. Much was collected as curios, war booty, or as "scientific" specimens, and not even considered worthy of being called art. Information about the artists was usually never discovered, because no one bothered to ask. Fortunately, diligent research both in Africa and in the museum collections is permitting identification of more and more artists by their style if not by their name. Hundreds of

Yoruba wood-carvers, for example, are now known. The situation regarding potters, traditionally a woman's artform throughout Africa, is unfortunately not as good. Perhaps because much of their art was considered primarily utilitarian, African women artists were doubly discriminated against or ignored.

A pioneering study of the Yoruba potter Abatan, conducted by Robert Thompson (1969), fortunately shows the potential for more similar research. This pot was made by that artist, a master potter from the village of Oke-Odan in the Egbado Yoruba area of southwestern Nigeria. At twelve, Abatan began working in clay as had her mother and grandmother, both distinguished potters. She began with simple utilitarian forms such as soup pots and only mastered the technique of making the ritual bowls, like this, when she was more than thirty years old. Her eventual fame was such that her work was in demand not only in her own Egbado area but also to the south in Aworri and to the west in Anago. The vessel is called an *awo ota eyinle*, meaning a vessel for the stones of the deity Eyinle. Eyinle is variously described as either a farmer or diviner who sacrificed himself by entering the earth and became transformed into a flowing stream of fresh water. Devotees of the deity must, at the minimum, have an iron chain bracelet as a mark of initiation, and this type of lidded vessel filled with fresh water and stones.

The vessel is composed of a lid (*omoori*) and pot (*iya*). The latter is decorated with symbols in low relief, the lid with a crown structure, roulette impressions, and indications (head, breasts, arms, hands), built upon the structure of the crown, of a woman holding a kola bowl. The *awo ota eyinle* is believed to enclose a portion of the river that Eyinle created, and with which he subsequently founded a royal city. The water, associated with the love of Eyinle for his children, is by extension an emblem of the "coolness" (concern, calm, order) without which the conditions that fulfill the spiritual dimension of life cannot be formulated (Thompson 1969:151). ▮

Transitions and Dealing with Adversity

This section is concerned with the transitions that are made by people as they change from one stage in their lives to another—child to adult, adult to elder, unmarried to married—and the associated artforms that mark these transitions. It is also explores the ways that people discover the cause of a problem or adversity, and seek resolution. Anthropologists have noted the similarities in the celebrations and rituals about transitions in the human life cycle seen around the world. Confirmations, initiations, graduations all are examples of rites of passage (van Gennep [1908] 1960). Victor Turner (1969) has also shown that these rites of passage proceed in three stages, beginning with separation, moving on to transition, and ending with incorporation. In Africa, a common initiation sequence sees young people taken from their homes to initiation camps. While in the camps they are in transition for they are no longer children but not yet adults. Their incorporation back into society comes at the celebrations, when they come back from the camps and are celebrated as adults. Art figures prominently throughout these phases.

Two masks, the Yaka people's *Kholuka* and the Chokwe people's *Chikunza*, are used in boys' initiation into manhood. They are both part of an institution known as *mukanda* that is shared by a number of people in Zambia, Angola, and the Democratic Republic of the Congo. Boys are circumcised, undergo physical challenges, learn about their history and learn the secrets of masks and the spiritual realm. They also are taught what their future roles will be as husbands and fathers. While each ethnic group shares in these goals, they each do it in their own way and therefore the range of masquerades associated with *mukanda* is quite broad. Among the Bamana of Mali, youth associations exist apart from initiation associations. They are composed of both male and female members, the young men range in age from fourteen to forty, the young women from twelve until they marry at age eighteen or nineteen. During this stage of life they learn about themselves and their cultural heritage and as part of this process compose, construct, and perform an elaborate puppet theatre. Transitions are not confined only to initiation for young people, and among many societies there are sequences of initiations that can last throughout a person's life. The Igbo Maiden Spirit masquerade, for example, is performed by middle-aged men. Most masquerades in Africa are performed by men, but the Igbo Elephant mask provides an interesting exception, since women have also started performing it.

Individuals and families in Africa often go to diviners when mishaps happen, conflicts break out, or a death occurs. Unlike many other parts of the world where astrological readings and horoscopes look to the future, in most of Africa, divination focuses on the past. What past activity or neglect of a spirit or ancestor is the real cause of the misfortune? By discovering the cause they can act to solve the problem and anticipate a better future. The diviner will often use artforms such as trays, baskets, or sculpture as part of the ritual and their aesthetic quality enhances the effectiveness of the procedure. Divination systems are often encapsulations of peoples' understanding of the structure of the world, and the Chokwe divination basket is an excellent example, for the objects and figures contained in the basket all relate or symbolize an aspect of human life. ∎

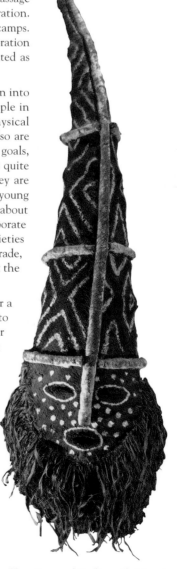

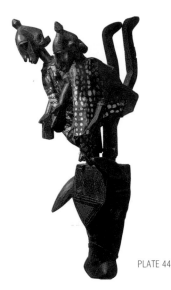

PLATE 44

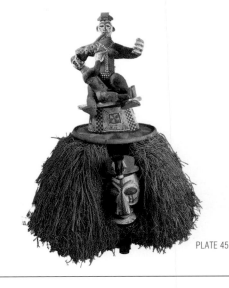

PLATE 45

PLATE 44. Puppet/mask (Sigi)

Yaya Coulibaly (1959 -)
Bamana peoples, Mali, 1987
Wood, cloth, string
Dimensions H x W x D: 83.8 x 33 x 25.4 cm (33 x 13 x 10 in.)
Collection of Craig A. Subler
Photograph by Lindsay Kromer

From the age of fourteen until their mid forties, young men of central Mali (both bachelors and married men) belong to the village youth association. During this period young men are at their physical peak, are expected to provide occasional communal labor (such as constructing or repairing public roads and buildings, and helping with harvest activities), and also to become socialized as adults in the society. Women also belong to the youth association and have their own section. They join at the age of puberty and remain as members until they marry (from approximately ages twelve to eighteen). This stage in life is seen as a time to learn about both oneself and one's cultural heritage, and as part of this process the youth associations stage elaborate puppet masquerades in which masks/puppets such as this one are used. Because of the strong influence of Islam in this part of Mali many areas have abandoned the initiation associations that previously coexisted with the youth associations (such as Ntomo, Chiwara and Kore). The youth association, therefore, has become the most important institutional socializing force in many areas (Arnoldi 1995:157, 160).

The puppet theater has been performed in the area since at least the mid-nineteenth century by the resident ethnic groups, such as the Bamana (farmers) and Boso (fishermen). Each year one performance is done in June as the rainy season is beginning, and another occurs in October at the beginning of the dry season when grains are harvested. Combining dance, song, music, puppetry, and masquerade, the performances start in late afternoon and last through the night. The youth association women sing and dance, and the men are the drummers, dancers, and masqueraders. A progression of as many as twenty-five to thirty different characters (masks and puppets) make appearances symbolically portraying the history and ethnicity of the performing groups and giving social commentary on life. This sculpture representing Sigi the buffalo, is called a rod puppet. A rod inserted into the back of the animal's head is held aloft by the puppeteer who is hidden in a costume below. By pulling on strings, the performer opens and closes the buffalo's mouth, wiggles its ears, and raises and lowers the arms and legs of the smaller rod puppets of a man and woman attached to the top of Sigi's head.

The image of Sigi as the lone bull buffalo symbolizes the elders. When Sigi performs with an array of small rod puppets on its back, the character reads as a microcosm of the village, past and present. The cluster of small puppets carried on Sigi's back feature people and animals drawn from domestic life and highlight particular occupations and gendered activities—for example, the farmer, women pounding millet,…Other characters represent different social strata and different ethnic groups.…Characters are also drawn from different historical periods: the precolonial warrior, the colonial administrator or military officer, and the president of the Republic of Mali. Sigi, here, stands as the symbol of cultural continuity and as the guardian of tradition. This version of the bush buffalo supports the commonly held beliefs which associate moral authority with the ancestors and with past time (Arnoldi 1995:182-183).

This buffalo stick puppet was made by Yaya Coulibaly in 1987. He grew up in a village and performed puppetry as a member of the local youth association but then went to school at the National Institute of Arts in Bamako, the capital of Mali. He founded his own puppet troupe, Groupe SOGOLON, and later became artistic director of the national puppet theater of Mali. As a talented sculptor, puppeteer, and playwright, he is an outstanding testament to the dynamic nature of puppet theater in Mali which uses such traditional characters as Sigi but in new contexts of performances within Mali and abroad (Arnoldi 1998).

PLATE 45. Mask (Kholuka)

Yaka people, Democratic Republic of the Congo (formerly Zaire), 20th century
Wood, polychrome, fiber
H: 71 cm (28 in.)
UCLA Fowler Museum of Cultural History
The Jerome L. Joss Collection
FMCH X83.978
Photo by Dennis J. Nervig
Photograph © UCLA Fowler Museum of Cultural History

This mask is associated with the types of rituals performed by a number of peoples in northern Angola, southern Democratic Republic of the Congo, and western Zambia that are known as *mukanda*. *Mukanda* are the initiation rituals allowing young men to undergo a change in social status and to make the passage from being a child to becoming an adult. Throughout this area the initiates undergo circumcision and are segregated away from the

PLATE 46

PLATE 47

rest of the population for a period of months or, in the past, even years. They are subjected to rigorous tests of endurance while under strict discipline, receive instructions in various things such as proper etiquette, learn songs, dances and masquerades, and are given some sex education. All activities are intended to prepare the boys for their upcoming roles as adult men and future fathers. The initiates often undergo a symbolic "death" and ultimately are "reborn" and reintegrated as adult members into their society with much public celebration.

Among the Yaka of southwestern Democratic Republic of the Congo, where this mask is from, there are a number of types of masks that are used during the initiation process and at the celebrations when the boys "graduate." Most are worn by the men conducting the initiation, but sometimes the initiates will learn how to perform one of the masks for their coming-out ceremony. This type of mask, known as *kholuka*, appears as the last of a series of masquerades at the final celebrations. One of its functions is as a charm bestowing the last measure of protection over the initiates. These kinds of masks are typically constructed of a wicker skeleton covered with raffia fabric, with only the face being carved of wood. Small figures are often attached to the conical coiffure, and they depict both humans and animals. The figures often illustrate some of the themes of the initiation: celebrating sexual differences, mocking deviant behavior, and often featuring explicit sexuality and childbirth scenes (Bourgeois 1984, 1993). On this particular mask the

imagery partakes of motifs sung by the *kholuka* performer and song leaders in the coming-out festivities. . . . the child attempts to wrest a pipe from its mother, apparently an allusion to over-eagerness to assume adult privileges (Bourgeois 1994:119)

PLATE 46. Mask (Chikunza)

Chokwe peoples, Angola/ Zambia, 19th or early 20th century
Wood, fibers, pigment
H x W x D: 136 x 38 x 29 cm (53 1/2 x 15 x 11 1/2 in.)
Private collection
Photograph by Lindsay Kromer

This mask, like the Yaka example, performs in the context of *mukanda*, the boys' initiation. It also, however, has broader associations among the Chokwe and related peoples (such as the Lunda, Luvale, Luchazi, and Mbunda) where it is part of a class of

masquerades known as *makishi*. *Makishi* represent the spirits of the deceased who return to guide and assist the community during important occasions. The Chokwe were a powerful kingdom in the 18th and 19th centuries and some of the *mukishi* functioned to sanction and validate political institutions (appearing at chiefs' installations and now even being used to promote political parties during national elections). Jordán notes that the *makishi* most commonly perform for the *mukanda* initiations which occur at the beginning of the dry season and that,

Makishi performances evoke the cosmological precepts of Chokwe and related peoples. Principles of social and political organization, history, philosophy, religion, and morality are presented publicly through *makishi* masquerades. In the context of the *mukanda* initiation for boys, the ancestral characters protect the initiation camp from intruders or evil *(wanga)* supernatural elements, and educate the novices in the privacy of the camp (1998:67).

The character represented in this mask is Chikunza, the patron and protector of the *mukanda* initiation camp. The word *chikunza* in Chokwe means a kind of grasshopper known for its procreative abundance, and so it symbolizes fertility. The tall, segmented, conical superstructure of the mask (made of a wicker base covered with painted bark-cloth) also represents the horn of a Roan antelope, a symbol of power and virility. Chikunza collects the uncircumcised boys from the village and leads them to the initiation camp. After the boys are circumcised and isolated in the initiation camp (in the past for up to a year but that is now usually much abbreviated) Chikunza functions as the camp's main protective spirit. Miniature amulets are carved in the shape of Chikunza to aid hunters, and infertile or pregnant women (Bastin 1984:42, 1993).

PLATE 47. Maiden Spirit Mask (Agbogho Mmuo)

Igbo peoples, Nigeria, early/mid-20th century
Wood, pigment, fabric
H: 40.7 cm (16 in.)
The Art Institute of Chicago
African and Amerindian Art Purchase Fund
1972.802
Photograph by Robert Hashimoto
Photograph © The Art Institute of Chicago

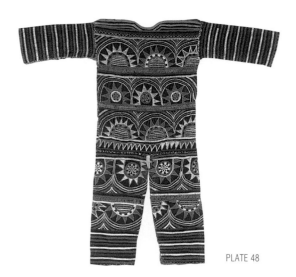

PLATE 48

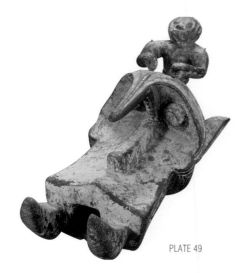

PLATE 49

PLATE 48. Masker Garment

Igbo peoples, Nigeria, 20th century
Cloth, fiber
H: 115.6 cm (45 1/2 in.)
Indianapolis Museum of Art
Gift of Mr. and Mrs. Harrison Eiteljorg
IMA1989.927A
Photograph © Indianapolis Museum of Art

Among the Igbo of Southern Nigeria, initiation marks the transition of boys into adulthood, and their entry into masking organizations. There is a hierarchical order of these masking associations divided into youth, younger men, middle-aged men, and elder categories. Each group performs with specific types of masks. The Igbo do not have any central political institutions, and authority is dispersed among entities such as councils, age-grade organizations and men's title-taking associations. The masking societies are therefore involved not only in the socialization processes associated with initiation, but also with social control activities. This elaborate wooden mask and the associated brightly colored costume are used in the maiden-spirit masquerades known as *Agbogho mmanwu* (or *mmuo*), which are common among the northern Igbo. They are performed by the middle-aged men's group (ages thirty to fifty) to extol the ideals of female beauty and represent the incarnate dead. The brightly colored costume is constructed of appliqued cloth and is inspired by the female body painting known as *uli*. The wooden mask also has some of the *uli* ornamentation painted on its delicately featured face, and has an impressively elaborate hairdo.

> Maidens are the pride of their fathers, the source of bride-wealth upon their forthcoming marriages. The ideal beauty of a girl has both physical and moral dimensions....Her moral qualities will include purity, obedience, good character, and generosity....These ideals are not often matched in reality, yet the maiden masquerade annually exaggerates them....These maidens are indeed larger than life, transcendent as representatives of the "incarnate dead." Their dances are based on those of real young girls, but they are executed by strong, tall men who take liberties with female styles, giving far more athletic and fast-paced performances (Cole and Aniakor 1984:121).

Concerned with maintaining social harmony in the village, the masks appear at initiations and at funerals of members of the association. The whitened face of the maiden spirit mask has nothing to do with racial distinctions but rather with philosophical principles of the Igbo. In much of the Igbo area there is a distinctly dual system of masquerades. White and light colored masks are associated with female attributes. They are gentle and benign and represent the order of civilization and the village. Dark masks are male, dangerous, associated with the unknown, and the mystery of the forest. Cole notes that the Igbo make the association that "white masks are said to come down from cumulus clouds: dark, ugly masculine masks from gray rain clouds" (1998).

PLATE 49. Elephant Mask (Ogbodo Enyi)

Igbo peoples, Nigeria, 20th century
W: 48.3 cm (19 in.)
UCLA Fowler Museum of Cultural History
The Jerome L. Joss Collection
FMCH X84.220
Photo by Denis J. Nervig
Photograph © UCLA Fowler Museum of Cultural History

Among the northeastern Igbo, masquerades are often organized in a different manner than other Igbo areas. The masquerade organization this mask is used for, is known as Ogbodo Enyi ("Spirit Elephant"). The organization includes both very young (uncircumcised) boys and adults but is arranged into age-grade divisions (uncircumcised youth, circumcised youth, married adults, and elders). While said to be an elephant, their masks tend to have small (or omitted) ears and the trunk is displaced to the middle of the forehead, so they are clearly more interested in the concept of "elephant" as a dangerous and powerful animal than in a lifelike interpretation. The masks appear during dry season festivals when the communities are ritually purified by elders and priests, and physically cleaned by the age-grade groups. Often four or five of these masks perform at the same time, but only for the junior grades. The elder grade masks perform one at a time. The masks of the most senior group are the only ones that can have a head or figure (as in this example) carved at the back of the head. The wooden masks worn on top of the head and the accompanying bell-shaped raffia costumes can weigh more than twenty pounds. The energetic performances, where masqueraders can be running and dancing throughout the village for up to six hours, exemplify the competitive nature of the age-grades (Weston 1984, Cole 1992).

In 1975 the village of Nkaliki in this area experienced a devastating number of children's deaths. Petitions were presented to the community oracle and the effort succeeded in stopping the deaths. In return the priestess of the oracle asked the women of

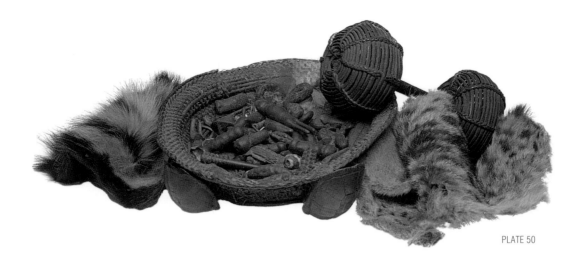

PLATE 50

Nkaliki to organize and dance Ogbodo Enyi in its honor. Throughout Africa masquerades are almost exclusively a male domain, so this was indeed very unusual. The women usually perform their mask twice a year and never at the same time as the men's performances. While the men's performances are very competitive, the women's are not. Rather than differentiating their organization into hierarchical age-grades as the men do, the women are collectively represented by a single mask (Weston 1984:153-159).

PLATE 50. Divination basket and rattle (Ngombo ya cisuka)

Chokwe peoples, Angola/ Zambia, 19th or early 20th century
Fiber, tortoise shells, animal skins, various materials
Dia.: 30.5 cm (12 in.)
Private collection

When African people have problems or come into conflict with others, they frequently seek help from a diviner. Contrary to popular generalizations, diviners are not "fortune-tellers" who can predict the future, but rather are "problem-solvers" who help people determine what problem in their past has caused their current difficulties and how to go about setting things right for the future. Throughout much of central and southern Africa diviners are known as *nganga* and are frequently said to gain the supernatural abilities to undertake their work from powerful ancestors. For the Chokwe and related peoples of Angola and western Zambia that is the case, and the *nganaga* here utilize a number of different techniques to do their work including using divination baskets such as this. Cases brought to them include illness, death, infertility, and theft, and the diviner must find out if these are related to social problems, interpersonal estrangements, ancestral induced afflictions or witchcraft (Bastin 1982; Rodrigues de Areia 1985). Divination systems around the world frequently are highly refined encapsulations of cosmological notions. In this Chokwe case, the basket is filled with symbolic figurines, natural objects, and found artifacts that relate to all aspects of life. When a client comes to consult the diviner he shakes up or tosses the objects thus invoking the Chokwe epistemology (theory of knowledge) or as Jordán (1996) has aptly put it, "Tossing Life In A Basket." Depending on what object comes to the top near the edge of the basket closest to the diviner, the cause of the client's symptom can be determined and a course of action prescribed.

Of all the Chokwe divinatory tools (*ngombo*) the divination basket (*ngombo ya cisuka*) is the most highly regarded. The objects placed in the basket are known as *tupele*. Westerners are particularly interested in the small figurative *tupele* with their variety of miniaturized abstracted humans in a variety of poses, tools, animals, and masked figures (see LaGamma 2000:46-48). In isolation the figures mean nothing, and so it is important to view the whole assemblage as an ensemble. When this divination basket was collected, fortunately, information about its use and contents was also available. It was owned and used by three different diviners living in Angola, and then in Zambia throughout the entire 20th century, until finally being deactivated when it was no longer being used. The rattle is used by the diviner "to invoke the powers of his tutelary ancestor, or *hamba kayongo*" (Jordán 1998:168, fig118). There are over 100 pieces from the basket, some passed along from diviner to diviner and others added over the years. The tortoise shells on the outside of the basket are packed with medicines to make the divination basket strong and invincible, just as the tortoise's shell protects the tortoise. A genet and skunk skin are attached because, like these nocturnal, elusive animals who can use their scent glands to scare away enemies, the diviners can move about in unseen ways and protect themselves. Objects inside the basket range from a few carved human and animal images to shells, horns, and seeds to collected objects like a spoon, a baby doll hand, and a fragment of false teeth, each associated with a particular meaning (Personal communication, Jordán 2002).

Connecting with the World

This section deals with artforms which illustrate how Africa has interacted with the rest of the world. Contemporary arts are one of the principle foci (see "This is African Art? Now You Confuse Me" by dele jegede, pages 9–15, and Plates 5, 7, 8, 10, 11) because their intended audience goes primarily beyond local populations to include foreign visitors and international art galleries and museums. But connecting with the world is not just a 20th century phenomenon as evidenced by the 16th or 17th century Benin plaque depicting Portuguese men. Likewise the Kongo kingdom's 15th century embracing of Christianity led to its adopting and then transforming the style and meaning of crucifixes. Christianity goes back even further in time in Ethiopia. Established in the fourth century, Ethiopian Christianity kept its early eastern Orthodox character and was largely isolated thereafter from the rest of Christendom. The Ethiopian painting (see Plate 53), in addition to depicting this African form of Christianity, also alludes to aspects of colonialism, another form of interaction with the world. In this painting the defeat of the Italian forces in 1896 at the battle of Adwa is depicted. Ethiopia was consequently one of the only African countries not to be colonized by Europe.

During the horrible centuries of Europe's participation in the African slave trade there were few attempts to proselytize Christianity in Africa. In the Americas, where most African slaves were taken, Christian interaction with African indigenous beliefs occurred. The most well-known examples include the Voudoun religion of Haiti, Candomble of Brazil, and Santeria of Cuba. The Santeria crown (see Plate 6) provides an excellent African Diaspora (or dispersion of Africans) example, for the crown was made to honor a Yoruba deity, Obatala, the god of creativity. Obatala is also syncretized in Santeria with the Virgin Mary, "Our Lady of Mercy." In Africa, Christianity never made large inroads again until the era of European colonialism when it was accompanied by other aspects of Western culture such as schools and hospitals. Christianity is now such an internalized belief pattern that there are more Christians in Africa than there are in the United States. How important Christianity has become is seen, for example, in the commemorative cloths produced to celebrate the consecration of the Côte d'Ivoire (Ivory Coast) Basilica Notre Dame de la Paix. The basilica is a massive replica of St. Peter's, built by the President of Côte d'Ivoire, Felix Houphouet-Boigny. A second example commemorates the visit of Pope John Paul II to consecrate the Basilica.

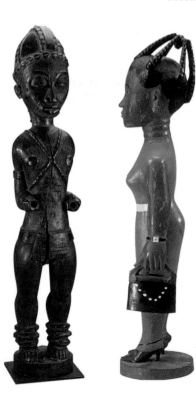

Islam made advances into Africa principally through trade, in both West Africa with the trans-Saharan trade, and along the east side of Africa through the seafaring trade to the Swahili coast. From the seventh century onwards, Islam made steady advances into Africa. In some areas the non-figurative, geometric nature usually associated with Islam artistry occurs (see the Swahili mat in Plate 1). Elsewhere Islam and Africa's interaction was more pragmatic in relation to the visual arts, as masks, protective amulets, and figures continue to be used by some West African Muslim peoples. The glass-painting tradition of Senegal provides a fine contemporary example of African Islamic connections to the outer world.

In addition to these examples of religious connections with the world, there are many other examples of influences, inspirations and transformations. The Asante *akonkromfi* chair seen earlier in the "Leadership and Status" section shows how an alien form can be adapted rather than merely appropriated. The Baule figures featured at left and on the cover of this catalogue illustrate how tradition is not just thoughtlessly preserved and endlessly repeated, but rather is actively constructed and reconstructed by each generation. The Western dressed figures represent a Baule category of spirits known as Other-World mates. With the ongoing confluence of cultures occurring in Africa, these examples of connecting with the world make perfect sense. ▮

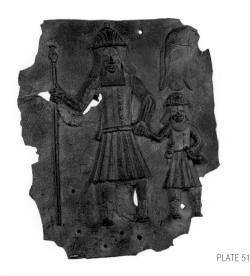

PLATE 51

PLATE 52

PLATE 51. Plaque depicting two Portuguese

Benin kingdom, Edo peoples, Nigeria, 16th–17th century
Copper alloy
Dimensions H x W x D: 42.7 x 36 x 4.3 cm (16 13/16 x 14 3/16 x 1 11/16 in.)
The Field Museum, Chicago
Gift of Mrs. A.W. F. Fuller
210352
Photograph by Diane Alexander White
Negative #A114184 7c

As the Portuguese were exploring for a route to the Far East, their ships pushed south along the west coast of Africa. By the 1470s or '80s they became the first Europeans to interact with the Kingdom of Benin. This was also the time of the great Benin warrior king, Esigie (introduced earlier on page 22), and diplomatic and trade relations were soon established. The Portuguese provided mercenary help to the kingdom and traded luxury items such as cloth, coral beads (for royal regalia), and large quantities of brass (for the manufacture of artworks). In return, Benin traded ivory, cloth, pepper, and slaves. This is also the time when, according to tradition, brass plaques started to be produced. There is some speculation that the Portuguese may have influenced their production by showing them books with pictures. The plaques ornamented the walls or house-posts of the royal palace, and holes for their attachment are evident. Production seems to have lasted only during the 16th and 17th centuries, and by the time of the British Punitive Expedition in 1897 the more than 900 plaques recovered were not in use and were found in a storage shed (Freyer 1987, Gershick Ben-Amos 1995).

The Portuguese presence in Benin was relatively brief for the French, Dutch, and English soon became the dominant trading partners, yet it is images of the Portuguese who predominate in Benin art. The Benin artists depicted the foreigners, paying close attention to the details of costume, weaponry and regalia, but in a standardized way depicting physical features of all Portuguese with the same thin straight noses and long hair. What is depicted is foreign, but the way in which they do it is typically Benin. What appears in this plaque to be a larger Portuguese male holding the hand of a Portuguese child may in fact be a typically Benin convention of differences in status (although the larger has a moustache, both have beards). On other plaques the *oba* or king is always the central and largest figure, and subordinates diminish in size according to their importance. The other important details of this plaque are the fish in the upper hand right corner and the

quatrefoil design on the background. Both have a deeper meaning and are associated with the god Olokun, sovereign of the oceans and provider of earthly wealth. The fish, along with other water creatures, are part of Olokun's realm, and the quatrefoil represent *ebe-amen*, or river leaves, which are used by Olokun priestesses in curing rites (Gershick Ben-Amos 1995:37-41). The foreigners thus had been internalized into Benin cosmology and became a symbol of the power and wealth then being amassed by the *oba* and his kingdom.

PLATE 52. Crucifix (Nkangi Kidutu)

Kongo peoples, Democratic Republic of the Congo (formerly Zaire), late 17th – early 18th century
Copper alloy
H x W x D: 33.3 x 14.9 x 2.9 cm (13 1/8 x 5 7/8 x 1 1/8 in.)
National Museum of African Art, Smithsonian Institution
Gift of Ernst Anspach
91-10-1
Photograph by Franko Khoury
Photograph © National Museum of African Art, Smithsonian Institution

The early Portuguese navigators also interacted with the great kingdom of the Kongo in central Africa. In the early 1480s Portuguese sailors had arrived in the Kingdom of the Kongo and brought with them, soldiers, traders, artisans, and Catholic missionaries. While the introduction of Christianity was unsuccessful in the Kingdom of Benin, here various chiefs converted and the king himself was baptised Dom João I (1491), as was his son, Alfonso I (1506-43). Thus a Christian state was established in Africa, though there are questions as to how extensive the Portuguese and Christian influence was. By the mid 1700s the Kongo kingdom had collapsed and all the Portuguese were gone.

Among the religious imagery introduced, crucifixes were prominent. While early ones may have more faithfully copied European prototypes, later, as is evidenced by this example, they were reinterpreted in a local Kongo style. The figure of Christ is obvious, but the identity of the other figures is uncertain. The two kneeling, praying figures on the cross's arms may be mourners or the two thieves crucified with Christ. The lower figure may be an apostle or the Virgin Mary (Sieber and Walker 1987: 124).

The meaning of these objects also departed from that of the originals. Historical and anthropological evidence attests to the great variety of meanings

PLATE 53

PLATE 54

attached to objects inspired by Christianity: they became symbols of authority, elements of investiture, healing accessories, oracles, and hunting talismans, among other things. There are many local names for these crucifixes. The most common are nkangi kiditu ("attached Christ"?) and santu ("santa cruz?) (Cornet 1981).

The cross form itself was an ancient cosmogram, or symbol, of the Kongo conception of the universe, called "the four moments of the sun." The horizontal line divides the world of the living from the land of the spirits and ancestors. The four ends of the cross correspond to the circular path that each individual takes during life—from birth, to the peak of life, to death, and then a parallel life as a spirit until being reincarnated as a child (Thompson and Cornet 1981).

PLATE 53. *Battle of Adwa*

Ethiopia, 1930
Canvas, paint
Dimensions H x W: 185.4 x 86.4 cm (73 x 34 in.)
National Museum of Natural History, Smithsonian Institution
Gift of Herbert and Sarita S. Ward
E394572
Photograph © National Museum of Natural History, Smithsonian Institution

Since the fourth century, Christianity has had a huge impact on the area of Africa that became known as Ethiopia. Fifteen centuries later more than 50 percent of the population are still affiliated with their inherited ancient form of Orthodox Christianity.

The story of the founding of the "Judeo-Christian" Kingdom of Ethiopia is preserved in an important book called Kebra Nagast, or "Glory of Kings." The teachings of the Kebra Nagast form the basis of the governing principles of this religious-led country, and is to Ethiopians what the Torah is to Jews and the Qur'an is to Muslims. The strength of the story and the spirit of Kebra Nagast has sustained Ethiopian Christianity, despite centuries of isolation from the rest of the Christian world. . . . The central teaching of the Kebra Nagast is that God selected the people of Ethiopia to replace the people of Israel as his chosen people. According to the Kebra Nagast, Ethiopian Christianity is a continuation of, rather than a rejection or replacement, of Ethiopian Judaism (Haile 2001:27).

To support these claims, the Kebra Nagast points out that the Ethiopians accepted the expected Messiah, and possess the Ark of the Covenant containing the Ten Commandments. Replicas of the

Ten Commandments are kept in churches in sacred boxes known as Tabot, and a very famous one, the Tabot of St. George is featured in this painting. The painting is of one of the most famous battles in Ethiopian history, the Battle of Adwa, where the emperor Menelik II defeated the Italians in 1896. The emperor, the archbishop of Ethiopia, Queen Taitu, and even the hovering Saint George can all be seen in the painting. Stylistic conventions that were used in Ethiopian religious art for centuries are still used in this 1930 painting. The righteous Ethiopians are depicted as full-faced figures, while the Italian enemy are in profile.

Until a century ago, Ethiopian painters did not concern themselves with profane subjects. . . . Rather, they devoted themselves to religious themes; their patrons were wealthy Ethiopians of the ruling class. It was only following Ethiopia's victory in the war against Italy that this tradition changed. As a result of the diplomatic recognition accorded Ethiopia in 1896, foreigners flooded into the country and began commissioning paintings from artists (Fisseha 1992: 331).

Silverman has noted that a number of European styles were influencing the Ethiopian painters at the end of the 19th century.

But this is not the first time foreign imagery had been introduced in Ethiopia or that foreign artists have worked in the country. European artists, as well as reproductions of European paintings and prints, have been coming to Ethiopia since at least the fifteenth century. In fact, it is interesting that most of the scholars who have written on the history of Ethiopian art have been preoccupied with tracing the influence these external elements have had on the evolution of Ethiopian religious painting. These authors celebrate the ingenuity with which these foreign traditions were assimilated by Ethiopian artists. Yet they fail to appreciate the same processes of integration operatiing in a modern context (1999:177-8).

The victory at Adwa secured Ethiopia's independence at a time when Europe was colonizing the entire continent of Africa. The Battle of Adwa is still celebrated as a national holiday in Ethiopia.

PLATE 54. Commemorative Roller Print of Basilique Notre Dame de la Paix, Yamoussoukro, Côte d'Ivoire

Designed and printed at Utexi, Côte d'Ivoire (Ivory Coast), 1990
Industrial wax print on cotton
Dimensions H x W: 119 x 181 cm (47 x 71 in.)
Collection of Kathleen Bickford Berzock
Photograph by Lindsay Kromer

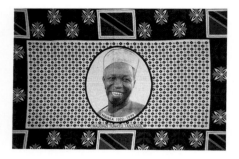

PLATE 55 PLATE 56 PLATE 57

PLATE 55. Commemorative Print at death of Tanzanian President Julius Nyerere

Printed at Mali Ya KTM, Tanzania, 1999
Industrial print on cotton
Dimensions H x W: 118 x 162 cm (46 1/2 x 63 3/4 in.)
Private Collection
Photograph by Lindsay Kromer

PLATE 56. Commemorative Java Print of Pope John Paul II

Printed at Vlisco, Helmond, Holland, 1990
Industrial Java print on cotton
Dimensions H x W: 119 x 177 cm (47 x 69 3/4 in.)
Collection of Kathleen Bickford Berzock
Photograph by Lindsay Kromer

PLATE 57. Printed Textile (Khanga)

Printed by Nisan Exports, Mumbai, India for Mali Ya Chavda, Zanzibar
Swahili saying "Usinionee Uchungu Riziki Kanipa Mungu" meaning
"Don't See Me as Suffering, God Gives Me Providence."
Industrial print on cotton
Dimensions H x W: 118 x 324 cm (47 1/2 x 128 in.)
Private Collection
Photograph by Lindsay Kromer

One of the most memorable aspects of visiting Africa, especially in a crowded setting like a city or market, is experiencing the incredible variety of colors and patterns in the factory-printed textiles worn by men and women. Factory-printed textiles are extremely popular throughout Africa and its most prevalent use is in three-piece women's outfits—skirt, blouse, and wrapper. Two principal types of factory-printed textiles are sold in most of Africa, roller prints called "fancy," and resist prints called "wax." European-produced cloth was the most prevalent in the first half of the 20th century but with the end of colonialism, post 1960s, African factories have largely taken over. Bickford notes that

> While differing significantly in quality, durability, and price, wax and fancy are conceived as two parts of a whole in Africa and valued in ways that are unrelated to their market value. Both are linked through historical association and frequently prized for the feelings of nostalgia that they can inspire. This kind of value is rooted in the importance of textiles of all sorts throughout West and Central Africa not only as commodities, but as symbols of wealth and a means of communicating ideas (1997:9)

The communicative functions of the cloth designs range from decorative, proverbial, and didactic to commemorative and funerary (see also Spencer 1982). A good example of a commemorative cloth, emphasizing the importance of the Christian religion in Africa, is seen in the Côte d'Ivoire piece of the Basilica Notre Dame de la Paix. The basilica is a massive replica of St. Peter's, built by the president of Côte d'Ivoire, Felix Houphouet-Boigny, and consecrated by Pope John Paul II in 1990. A second example, commemorating the pope's visit, was made in Holland, but with the African market in mind. Concerning such European fabrics John Picton has noted,

> One might argue, of course, that, as these fabrics are the products of European industry, they have no real place here; ...Moreover this opinion might seem to be reinforced by the colonial encouragement of any attempt to subvert local hand-production by the import of cheap alternatives, thereby transferring wealth from Africa to Europe. However, the facts of the history of wax and fancy prints turn this view on its head. Two companies still produce wax prints for sale in Africa: ...and it is evident from their various archives, firstly that these developments were contingent upon a local agency with a far greater determining role than has hitherto been realised, and secondly that the employees of these firms are kept in employment by African patronage (1995:25).

In east Africa, cloth known as *khangas* have been popular for more than one hundred and fifty years. Originally imported from Britain, the Netherlands, and India, locally manufactured cloth largely took over in the late 1960s. The commemorative cloth, made on the death of former Tanzanian President Julius Nyerere, is a good example of such Tanzanian-produced cloth. *Khangas* are sold as a pair of cloths, for a skirt and wrapper-type top and head covering, and are worn and owned by women. Women pick out cloth based on the design and quality of the cloth, but most importantly the Swahili proverb included in the design (Hilger 1995). The example from Zanzibar was manufactured in India, but clearly the designers were receiving input from Swahili speakers. The Swahili saying, which means "Don't See Me as Suffering, God Gives Me Providence," makes it obvious that they were aiming their sales at the Islamic Swahili population of the coastal region. "Riziki" is a word meaning the necessities of life, which Islamic Swahili restrict to meaning God's gift or providence.

PLATE 58 PLATE 59 PLATE 60

PLATE 58. *al-Buraq*

Mor Gueye
Senegal, 1990
Enamel on glass
H x W x D: 33.5 x 49 x 2.25 cm (13 3/16 x 19 5/16 x 7/8 in.)
Collection of Craig A. Subler
Photographed by Lindsay Kromer

PLATE 59. Amadou Bamba

Mor Gueye
Senegal, 1996
Enamel on glass
H x W x D: 48 x 32.5 x .5 cm (18 7/8 x 12 13/16 x 3/16 in.)
Private collection
Photographed by Lindsay Kromer

PLATE 60. Bus to Touba

Azoubade
Senegal, 1996
Enamel on glass
H x W x D: 24 x 32.2 x .5 cm (9 7/16 x 12 13/16 in.)
Private collection
Photographed by Lindsay Kromer

Reverse-glass paintings (brightly painted works done on the backs of panes of glass) are the most widely known Senegalese art form and are a staple of their tourist art industry. Much of the work is of subjects that will appeal to tourists, but some (represented by a few examples here) are Islamic in nature and intended for a Senegalese clientele. The winged horse is known as al-Buraq, the steed which took the Prophet Muhammad on his famous mystical night journey from Mecca to Jerusalem and then on to meet God in the dome of the seven heavens. Bravmann describes how mass-produced chromolithographs of this image (from Egypt) circulated widely in Islamic Africa and inspired many African amuletic and carved representations of the winged horse. He notes that Sufi Muslims "took the legend [of al-Buraq] as a virtual metaphor for their own existence. Muhammad's transcendent voyage was the passage that all Sufi sought to emulate, a path that all mystics attempted to follow in their own lives" (Bravmann 1983:75). Roberts and Nooter Roberts note that "in some places, al-Buraq

appears as a vehicle through which Muslims may articulate miraculous success in contemporary business. In this, it shares structural characteristics with the non-Islamic, nearly pan-African spirit Mami Wata (see Drewal 1988) as incarnating the vagaries of local and international capitalism (Roberts 1995:90)" (2003).

The bus seems at first glance to be just the type of genre scene tourists would love to buy of a typical colorful local vehicle with a tout hanging out the back and piles of luggage heaped on top. What tourists probably don't realize is that bus's destination, Touba, is the location of the most important mosque in Senegal. "The mosque is also the tomb of Sheik Amadou Bamba (1853-1927), the Sufi saint around whom the Mouride brotherhood has been formed. Mourides venerate Bamba's tomb, and every year well over a million souls come to Touba in a pilgrimage that in many ways replaces, or at least complements the Hajj pilgrimage to Mecca" (Roberts 1996). The other glass painting is of Sheik Amadou Bamba and is based on the only known photograph of the saint, taken in 1913. His stature as an anti-colonial resistance leader against the French partially accounts for the popularity of such images, but they are also intended as devotional images for the faithful. Widely reproduced images of the saint, such as this, are held to have active spiritual powers that can protect or heal those who own them (see Roberts and Nooter Roberts 2003 and their web site http://www.fmch.ucla.edu/passport/home.html).

Mor Gueye, one of the fathers of the Senegal reverse-glass genre, painted two of these images. He recalled how Amadou Bamba came to him in a dream before he painted his first image of the Saint. He now paints a number of scenes drawn from the life of the saint, especially the miracles divine providence allowed the Saint to perform to thwart the evil intentions of the French. Mor Gueye states that divine intervention inspires his compositions and that "even while painting for sale to tourists who may never know or even care what the sacred scenes present to the artist, reproducing the Saint's image is a devotional task well worth doing. And as other artists confirm, being able to sell images of Bamba confirms the Saint's power to care for his devotees" (Roberts and Nooter Roberts 2003).

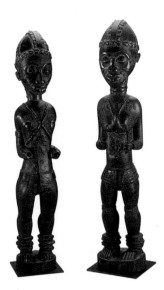

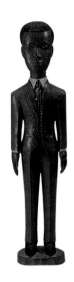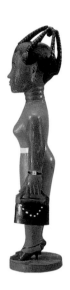

PLATE 61

PLATE 62

PLATE 61. Bush Spirit Figures (Asie Usu)

Baule, Côte d'Ivoire, 20th century
Wood, kaolin, animal hair
Male H: 48.5 cm (19 1/8 in.), Female H: 50 cm (19 11/16 in.)
UCLA Fowler Museum of Cultural History
The Jerome L. Joss Collection
Male FMCH X86.1739, Female FMCH X86.1740
Photo by Dennis J. Nervig
Photograph © UCLA Fowler Museum of Cultural History

PLATE 62. Other World Figures (Blolo Bian, Blolo Bla)

Baule, Côte d'Ivoire, male c. 1960, female c. 1965
Wood, enamel paint
Male H: 33.6 cm (13 1/4 in.), Female H: 39.5 cm (15 9/16 in.)
UCLA Fowler Museum of Cultural History
Anonymous Gift
Male FMCH X94.18.2, Female FMCH X94.17.5
Photo by Dennis J. Nervig
Photograph © UCLA Fowler Museum of Cultural History

This group of figures from the Baule people of Côte d'Ivoire show how African art can transform to adapt with the times, yet remain as vital assertions of long-held beliefs. Both the older pair of figures in traditional outfits, and the male and female figures in Western garb represent spirits, and all four conform to the Baule aesthetic conception of human beauty. Baule figures are intended to display the same standards of beauty desired in living people (Vogel 1980). Facial features are carefully delineated and the eyes are often downcast. Long necks are appreciated in Baule society and the neck-rings, or "beauty-lines," are seen on both the old and new female figures. Strong calf muscles are also appreciated and are seen especially on the older figures. Careful attention to coiffure, scarification, appropriate dress, and deportment all confirm that people of beauty and character are being depicted. Of all the divinities and spirits represented by the Baule, only the types of figures represented here are given human form and treated as if they are human.

The older figures, carved as a pair,

> represent bush spirits (asie usu), the denizens of the wild world beyond the edge of the village. They may arbitrarily intervene in the lives of individuals, possessing a person, disturbing the previous order and compelling him or her to act in abnormal ways. One result may be madness: another result may be the gift of clairvoyance, which makes a person into a trance diviner

(komien). To reestablish order, figures may be carved as intermediaries acknowledging the spirits (Ravenhill 1994a:55-56).

These asie usu figures were used by a diviner. The details seen on the pair—cowry shell decorated hats, medicine bandoleers, a flywhisk in the female's hand, and the cache-sexe each wear— accurately depict the costume and accoutrements of diviners. They were displayed during the public performances of trance diviners, a visual testimony that the diviner's spiritual empowerment was made possible by the personification of the wild bush spirits.

The other two figures, perhaps carved by the same artist, were never intended as a pair. They are Other-World figures, the male is known as a blolo bian, and the female as a blolo bla. In the spirit-realm where newborns come from and a dead person returns, each person has a partner of the opposite sex. When an Other-World mate makes their presence known and causes problems, a diviner may recommend that a figure be carved to remedy the problems caused by the Other-World mate's jealousy.

> The Other-World mate is also acknowledged by the act of reserving one designated night of the week as a time for the mate to visit in dreams. Every week, on the same night, the person sleeps alone and dreams about the Other-World person. The following morning, the figure is addressed and small offerings are made. In this way, one establishes an on-going relationship with the Other-World mate, and the problem that led to the commissioning and installation of the figure perhaps finds a resolution (Ravenhill 1994b:27).

While older Other-World figures look like the asie usu figures, contemporary ones (like their human counterparts) have been integrated into world society and are thoroughly cosmopolitan and urbane. ▮

Bibliography

Abiodun, Rowland
1975 "Ifa Art objects: An Interpretation based on Oral Tradition."
 In W. Abimbola (ed.) *Oral Traditions: Poetry in Music, Dance and Drama*. Ife: Department of African Languages and Literatures.
1987 "Verbal and Visual Metaphors: Mythic Allusions in Yoruba Ritualistic Art of Ori." *Word and Image* 3(3):252-270.
1994 "Ase: Verbalizing and Visualizing Creative Power through Art." *Journal of Religion in Africa* 24(4):294-322.

Armstrong, Robert Plant
1981 *The Powers of Presence: Consciousness, Myth and Affecting Presence*. Philadelphia: University of Pennsylvania Press.

Arnoldi, Mary Jo
1995 *Playing with Time: Art and Performance in Central Mali*. Bloomington: Indiana University Press.
1998 "Yaya Coulibaly, a Malian Puppeteer." *Puppetry International* 4:8-11.

Arnoldi, Mary Jo and Christine Mullen Kraemer
1995 *Crowning Achievements: African Arts of Dressing the Head*. Los Angeles: Fowler Museum of Cultural History, University of California, Los Angeles.

Beek, Walter van
1991 "Enter the Bush: a Dogon Mask Festival." In S. Vogel (ed.) *Africa Explores: 20th Century African Art*. New York: The Center for African Art.

Bastin, Marie-Louise
1961 *Art Décoratif Tshokwe*. Lisboa: Companhia de Diamantes de Angola, Serviços Culturais.
1982 *La Sculpture Tshokwe*. Paris: Alain et Francoise Chaffin.
1984 "Ritual Masks of the Chokwe" *African Arts* 17(4): 40-45, 92-93, 95.
1993 "The Akishi Spirits of the Chokwe" in Frank Herreman and Contantijn Petridis (eds.), *Face of the Spirits: Masks from the Zaire Basin*. Gent: Snoeck-Ducaju pp.79-95.

Beier, Ulli
1968 *Contemporary Art in Africa*. New York: Frederick A. Praeger.

Bellis, James
1982 *The "place of pots" in Akan funerary custom*. Bloomington, Indiana: African Studies Program, Indiana University.

Ben-Amos, Paula
1983 "In Honor of Queen Mothers" in Paula Ben-Amos and Arnold Rubin (eds.) *The Art of Power, The Power of Art: Studies in Benin Iconography*. Los Angeles: Museum of Cultural History, UCLA. pp. 79-83.

Bickford, Kathleen
1997 *Everyday Patterns: Factory Printed Cloth of Africa*. Kansas City: University of Missouri-Kansas City Gallery of Art.

Biebuyck, Daniel
1985 *The Arts of Zaire*, vol.1. Southwestern Zaire. Los Angeles: University of California Press.

Blackmun, Barbara Winston
1991 "Who Commissioned the Queen Mother Tusk." *African Arts* 24(2): 55-65, 90, 91.

Blier, Suzanne Preston
1995 *African Vodun: Art, Psychology, and Power*. Chicago: University of Chicago Press.

Bourgeois, Arthur P.
1982 "Yaka and Suku Leadership Headgear" *African Arts* 15(3) 30-5, 92.
1984 *Art of the Yaka and Suku*. Meuden: Alain and Francoise Chaffin.
1992 personal communication
1993 "Masks and Masking among the Yaka, Suku and Related peoples" in Frank Herreman and Constantijn Petridis (eds.), *Face of the Spirits: Masks from the Zaire Basin*. Gent: Snoeck-Ducaju pp.49-61.
1994 "Mask, Yaka, Zaire" in Doran H. Ross (ed.) *Visions of Africa: The Jerome L. Joss Collection of African Art at UCLA*, Los Angeles: Fowler Museum of Cultural History, University of California, Los Angeles.
2001 "Yoruba Door in the Indianapolis Museum of Art" Unpublished Manuscript.

Bravmann, René A.
1974 *Islam and Tribal Art in West Africa*. Cambridge: Cambridge University Press.
1983 *African Islam*. Washington D.C.: Smithsonian Institution Press.

Brett-Smith, Sarah
1982 "Symbolic Blood: Cloths for Excised Women." *RES* 3 (Spring):15-31.
1983 "The Poisonous Child." *RES* 6 (Fall):47-64.

Brown, H. D.
1944 "The Nkanu of the Tumba: Ritual Chieftainship on the Middle Congo." *Africa* 14(8):431-447.

Bryant, A. T.
1970 (1948) *The Zulu People as they were before the white man came*. New York: Negro Universities Press

Burton, William
1961 *Luba Religion and Magic in Custom and Belief*. Tervuren: Musee Royal de l'Afrique Centrale.

Cameron, Elizabeth
1996 *Isn't S/He a Doll? Play and Ritual in African Sculpture*. Los Angeles: UCLA Fowler Museum of Cultural History.

Celis, George
1970 "The Decorative Arts in Rwanda and Burundi." *African Arts* 6:1(Autumn)40-42.

Chaffin, Alain and Françoise Chaffin
1979 *L'Art Kota: Les figures des reliquaries*. Paris and Meudon.: Chaffin

Cole, Herbert M.
1982 *Mbari: Art and Life among the Owerri Igbo*. Bloomington, Indiana: Indiana University Press.
1992 "The Igbo: Prestige Ivory and Elephant Spirit Power." in Doran Ross (ed.) *Elephant: The Animal and Its Ivory in African Culture*. Los Angeles: Fowler Museum of Cultural History, University of California, Los Angeles. pp. 210-225.
1998 "Igbo Art in Social Context" Field Research Essay in Christopher Roy (ed.) *Art and Life in Africa, CD-ROM*. Iowa City: Art and Life in Africa Project, The University of Iowa.

Cole, Herbert M. (Editor).
1985 *I Am Not Myself: The Art of African Masquerade*. Los Angeles: UCLA Museum of Cultural History.

Cole, Herbert M and Chike C. Aniakor
1984 *Igbo Arts: Community and Cosmos. Los Angeles*: Museum of Cultural History, University of California, Los Angeles.

Cole, Herbert M. and Doran Ross
1977 *The Arts of Ghana*. Los Angeles: University of California, Museum of Cultural History.

Cornet, Joseph
1981 Catalogue entry, "Kongo Crucifix," in Susan Vogel (ed.) *For Spirits and Kings: African Art from the Paul and Ruth Tishman Collection*. New York: The Metropolitan Museum of Art, p. 205

Cuypers, Jan-B.
1987 "Esthetique au Rwanda Traditionel" in *Recherche Scientifique au Rwanda par le Musee de Tervuren*. Tervuren: Musee Royal de L'Afrique Centrale, pp. 39-47.

Danilowitz, Brenda
1993 "John Muafangejo: Picturing History." *African Arts* 26 (2):46-57.

David, Nicholas, Judy Sterner, and Kodzo Gavua.
1988 Why Pots are Decorated," with comment. *Current Anthropology* 29 (3):365-390.

DeMott, Barbara
1982 *Dogon Masks: A Structural Study of Form and Meaning*. Ann Arbor, Michigan: UMI Research Press.

Dewey, William J.
1993 *Sleeping Beauties*. Los Angeles: Fowler Museum of Cultural History.

Dewey, William J. and S. Terry Childs
1996 "Forging Memory" in Mary Nooter Roberts and Allen F. Roberts
 (eds.), *Memory: Luba Art and the Making of History*.
 New York: The Museum for African Art. pp. 61-84.

Dewey, William and Els De Palmenaer (eds.)
1997 *Legacies of Stone: Zimbabwe Past and Present*.
 Tervuren: Royal Museum for Central Africa, 1997.

Dewey, William J. and Allen F. Roberts
1993 *Iron, Master of Them All*. Iowa City: The University of of Iowa Museum
 of Art and The Project for Advanced Study of Art and Life in Africa.

Dieterlen, Germaine
1989 "Masks and Mythology among the Dogon."
 African Arts 22 (3):34-43, 87-88.

Drewal, Henry John
1988 "Performing the Other: Mami Wata Worship in Africa."
 TDR, The Drama Review 32(2): 160-185.
1996 "Mami Wata Shrines: Exotica and the Construction of Self."
 In *African Material Culture*, edited by M. J. Arnoldi, C. Geary and K.
 Hardin. Bloomington, IN: Indiana University Press.

Drewal, Henry John, John Pemberton III, and Rowland Abiodun
1989 *Yoruba: Nine Centuries of African Art*. New York: The Center for African Art.

Drewal, Henry John and John Mason
1998 *Beads, Body and Soul: Art and Light in the Yoruba Universe*.
 Los Angeles: Fowler Museum of Cultural History, UCLA.

DjeDje, Jacqueline C. (ed.)
1999 *Turn Up the Volume! A Celebration of African Music*.
 Los Angeles: UCLA Fowler Museum of Cultural History.

Fagg, William
1982 *Yoruba Sculpture of West Africa*. New York: Alfred Knopf.

Fernandez, James W.
1982 *Bwiti: An Ethnography of the Religious Imagination in Africa*.
 Princeton, NJ: Princeton University Press.

Fernandez, James W., and Renate L. Fernandez.
1976 "Fang Reliquary Art: Its Quantities and Qualities." *Cahiers d'Etudes
 Africaines* 60 (15-4):723-746.

Fisseha, Girma
1982 "Under the Gun: Elephants in Ethiopian Painting." in Doran Ross (ed*.)
 Elephant: The Animal and Its Ivory in African Culture*. Los Angeles:
 Fowler Museum of Cultural History, University of California,
 Los Angeles. pp 331-343.

Förster, Till
1988 *Die Kunst der Senufo: Museum Rietburg Zurich, Aus Schweizer
 Sammlungen*. Zurich: Museum Rietburg.
1993 "Senufo Masking and the Art of Poro." *African Arts* 26 (1):30-41, 101.

Freyer, Bryna
1987 *Royal Benin Art in the Collection of the National Museum of
 African Art*. Washington D.C.:Smithsonian Institution Press.

Garrard, Timothy F.
1980 *Akan Weights and the Gold Trade*. London:Longman.
1983 Akan Pseudo-Weights of European Origin." in Doran H. Ross and
 Timothy F. Garrard (eds), *Akan Transformations: Problems in Ghanaian
 Art History*. Los Angeles: University of California, Museum of Cultural
 History.

Geary, Christraud M.
1992 "Elephants, Ivory and Chiefs: The Elephant and the Arts of the
 Cameroon Grasslands." In Doran Ross (ed.) *Elephant: The Animal
 and Its Ivory in African Culture*. Los Angeles: Fowler Museum of
 Cultural History, University of California, Los Angeles. pp. 228-257.

Gennep, Arnold van
1960 [1908] *The Rites of Passage*. Chicago: University of Chicago Press.

Gershik Ben-Amos, Paula
1995 *The Art of Benin* (Revised Edition).
 Washington D.C.: Smithsonian Institution Press.

Gibson, Gordon D. and Cecilia R. McGurk
1977 "High Status Hats of the Kongo and Mbundu Peoples."
 Textile Museum Journal 4(4):71-96.

Gilbert, Michelle
1989 "Akan Terracotta Heads: Gods or Ancestors?"
 African Arts 22(4)34-43, 85, 86.

Gilfoy, Peggy Stoltz
1987 *Patterns of Life: West African Strip-Weaving Traditions*.
 Washington D.C.: Smithsonian Institution Press.

Glaze, Anita
1975 "Woman Power and Art in a Senufo Village."
 African Arts 8 (3):20, 29, 64-68, 90.
1981 *Art and Death in a Senufo Village*.
 Bloomington: Indiana University Press.
1986 "Dialectics of Gender: Senufo Masquerades."
 African Arts 19 (3):30-39, 82.

Griaule, Marcel
1970 *Conversations with Ogotemmêli: An Introduction to Dogon religious
 Ideas*. London: Oxford University Press.

Haas, Mary de
1998 "Beer." in Brendan Bell and Ian Calder (eds)
 Umbunda: Aspects of Indigenous Ceramics in KwaZulu Natal.
 Pietermaritzburg: Tataham Art Gallery.

Hackett, Rosalind I. J.
1996 *Art and Religion in Africa*. London: Cassell.
1998 "Art as Neglected 'Text' for the Study of Gender and Religion in
 Africa." *Religion* 28 (4):363-370.

Haile, Getatchew
2001 "Daily Life and Religious Practices in Ethiopia."
 In Deborah Horowitz (ed.) *Ethiopian Art: The Walters Art Museum*.
 Baltimore: The Walters Art Museum. pp. 19-44.

Heathcote, David
1972 "Hausa Embroidered Dress." *African Arts* 5(2)12-19, 82, 84.

Hilger, Julie
1995 "The Kanga: An Example of East African Textile Design"
 in *The Art of African Textiles: Technology, Tradition and Lurex*.
 London: Barbican Art Gallery. pp. 44-45.

Homberger, Lorenz
1994 "Cameroon," in Sandro Bocola (ed.)
 African Seats. New York: Prestel. pp. 86-89.

Houlberg, Marilyn Hammersly
1973 "Ibeji Images of the Yoruba" *African Arts* 7(1)20-27,91,92.

Ikenga Metuh, E.
1985 *African Religions in Western Conceptual Schemes*.
 Bodija, Ibadan, Nigeria: Pastoral Institute.

Jewsiewicki Bogumil
1995 *Chéri Samba: The Hybridity of Art*. Westmount, Quebec: Galerié
 Amrad Contemporary African Artists Series 1.

Johannesburg Art Gallery
1991 *Art and Ambiguity. Perspectives on the Brenthurst
 Collection of Southern African Art*.
 Johannesburg: Art Gallery/ Johannesburg City Council.

Jordán, Manuel
1996 "Tossing Life in a Basket: Art and Divination among Chokwe, Lunda,
 Luvale, and Related Peoples of Northwesrn Zambia."
 Unpublished Ph.D. Dissertation, The University of Iowa.
1998 (ed.) *Chokwe! Art and Initiation Among Chokwe and Related Peoples*.
 New York: Prestel
1998 "Engaging the Ancestors: Makishi Masquerades and the transmission
 of Knowledge Among Chokwe and Related Peoples."
 In *Chokwe! Art and Initiation Among Chokwe and Related Peoples*.
 New York: Prestel, pp. 67-75.
2000 "Art and Divination Among Chokwe, Lunda, Luvale and
 other Related Peoples of Northwestern Zambia"
 in John Pemberton III (ed.) *Insight and Artistry in African Divination*.
 Washington: Smithsonian Institution Press, pp.134-143

Kaplan, Flora
2000 "Queen Mother Head." In John Mack (ed.) *Africa Arts and Cultures*.
 New York: Oxford University Press. pp. 14-15.

Kerchache, Jacques, Jean-Louis Paudrat, and Lucien Stéphan, eds.
1993 *Art of Africa*. New York: Harry Abrams.

Klopper, Sandra
1991 "'Zulu' Headrests and Figurative Carvings: The Brenthurst Collection
 and the Art of South-east Africa." in *Art and Ambiquity. Perspectives
 on the Brenthurst Collection of Southern African Art*.
 Johannesburg Art Gallery/ Johannesburg City Council. pp.80-98.
1995 "Lidded Vessel." in Tom Phillips (ed.) *African Art of a Continent*
 London: Royal Academy pp.222-223.

Kraemer, Christine Mullen
1995 "Practical Beauty: Headgear for Daily Living." In Mary Jo Arnoldi and
 Christine Mullen Kraemer (ed.) *Crowning Achievements: African Arts
 of Dressing the Head*. Los Angeles: Fowler Museum of Cultural
 History, University of California, Los Angeles.

Kriger, Colleen
1988 "Robes of the Sokoto Caliphate."
 African Arts 21(3) 52-57, 78, 79, 85, 86.

LaGamma Alisa
2000 *Art and Oracle: African Art and Rituals of Divination*.
 New York: The Metropolitan Museum of Art.

Laburthe-Tolra, Philippe, and Christiane Falgayrettes-Leveau
1991 *Fang*. Paris: Musée Dapper.

Lamp, Frederick
1985 "Cosmos, Cosmetics, and the Spirit of Bondo".
 African Arts 18 (3):28-43.

Laufer, B., W. D. Hambly and R. Linton.
1930 *Tobacco and its Use in Africa*. Chicago: Field Museum of Natural History.

Lucas, Stephen A.
1966-67 "L'Etat traditionnel Luba." *Problemes Sociaux Congolais*.
 74:83-97, 79:93-116.

Lewis-Williams, J. D. , and Thomas A. Dowson
1989 *Images of Power: Understanding Bushman Rock Art*.
 Johannesburg: Southern Book Publishers.
1990 "Through the Veil: San Rock Paintings and the Rock Face."
 South African Archaeological Bulletin 45:5-16.

Mack, John
1986 *Madagascar, Island of the Dead*. London: Museum of Mankind.

John Mack (ed.)
2000 *Africa: Arts and Culture*. New York: Oxford University Press.

MacGaffey, Wyatt, and Michael D. Harris, eds.
1993 *Astonishment and Power. The Eyes of Understanding : Kongo Minkisi
 : Resonance, Transformation, and Rhyme : The Art of Renee Stout*.
 Washington, DC: Smithsonian Institution Press.

Magava, E. B.
1973 "African customs connected with the burial of the dead in Rhodesia."
 In A. J. Dachs (ed.) *Christianity South of the Zambezi*.
 Gwelo: Mambo Press.

Mahachi, G.
1987 "The Duma of South-eastern Zimbabwe: a preliminary analysis of a
 Shona burial practice." *Zimbabwe Science News*. 21.11-12:141-144.

Mazrui, Ali A.
1986 *The Africans: A Triple Heritage*. London: BBC Publications.
1994 "Islam and African Art: Stimulus or Stumbling Block?"
 Africa Arts 27 (1):50-57.

McNaughton, Patrick R.
1988 *The Mande Blacksmiths: Knowledge, Power and Art in West Africa*.
 Bloomington, IN: Indiana University Press.

Mercier, Jacques
1979 *Ethiopian Magic Scrolls*. New York: George Braziller.
1992 *Le Roi Salomon et Les Maîtres du Regard: Art et Médécine*.
 Paris: Editions de la Réunion des Musées Nationaux.

Milbourne, Karen E.
2002 "Diplomacy in Motion: Art, Pageantry and the Politics of Creativity
 in Barotseland." Ph.D. Thesis, The University of Iowa.

Ndekesi, Sylvestre.
1986 *Les Metiers Traditionneles du Rwanda*. Kigali, publisher unknown.

Nettleton, Anitra
1984 "The Traditional Figurative Woodcarving of the Shona and Venda."
 unpublished Ph.D. dissertation, University of Witwatersrand.
1988 "History and the Myth of Zulu Sculpture."
 African Arts 21.3:48-51,86,87.
1990 "'Dream Machines': Southern African Headrests."*South African
 Journal of Art and Architectural History*. 1.4:147-154.
1991 "Tradition, Authenticity and Tourist Sculpture in 19th and
 20th Century South Africa." in *Art and Ambiquity. Perspectives
 on the Brenthurst Collection of Southern African Art*. Johannesburg Art
 Gallery/ Johannesburg City Council, pp.32-47.

Nicolls, Andrea
1999 "Ekonda Ceremonial Blade and Hat" *in Selected Works from the
 Collection of the National Museum of African Art*. Washington D.C.:
 Smithsonian National Museum of African Art. pp. 145-6.

Nooter, Mary H. (Polly)
1984 "Luba Leadership Arts and the Politics of Prestige."
 unpublished M.A. thesis, New York: Columbia University.

Nooter, Mary H. (Polly) (ed.)
1993 *Secrecy: African Art that Conceals and Reveals*.
 New York: The Museum for African Art.

Nooter Roberts, Mary H.
1995 "Luba ceremonial Spear" in *Treasures From the Africa-Museum,
 Tervuren*. Tervuren:Royal Museum for Central Africa. pp. 357-358.

Nooter Roberts, Mary and Allen F. Roberts
1996 *Memory: Luba Art and the Making of History*.
 New York: The Museum for African Art.

Northern, Tamara
1984 *The Art of Cameroon*. Washington D.C.: Smithsonian Institution.

Notue, Jean Paul
2000 " Elephant Mask." In John Mack (ed.) *Africa: Arts and Culture*.
 New York: Oxford University Press. pp. 112-115.

Ogungbile, David O.
n.d. "Communication through Religious Iconography: the Example of
 Osogbo Art and Life" (unpublished paper).

Ottenberg, Simon.
1994 "Ambiguity and Synthesis in Religious Expression in Contemporary
 Eastern Nigerian Art." Paper read at Tenth Satterthwaite Colloquium
 on African Religion and Ritual, at U.K.

Papini, Robert
1995 "Beer Vessel." in Tom Phillips (ed.) *African Art of a Continent*
 London: Royal Academy pp.220-221.

Parkin, David
1986 "An Introduction to the Society and Culture of the Mijikenda."
 in Ernie Wolfe, *Vigango. Commemorative Sculpture
 of the Mijikenda of Kenya*. pp.17-23.

Perani, Judith and Norma Wolff
1992 "Embroidered Gown and Equestrian Ensembles of the Kano
 Aristocracy." *African Arts* 25(3)70-81, 102-104.

Perrois, Lois
1985 *Ancestral Arts of Gabon: from the Collections of the Barbier-Mueller
 Museum*. Translated by Francine Farr.
 Geneva: Barbier-Mueller Museum.

Phillips, Tom
1995 *Africa. The Art of a Continent*. New York: Prestel.

Picton, John
1990 "What's in a Mask?" *African Languages and Cultures* 3 (2):181-202.
1994 "Art Identity and Identification: A Commentary on Yoruba Art
 Historical Studies." In Abiodun, Rowland; Henry J. Drewal and John
 Pemberton III (ed.) *The Yoruba Artist: New Theoretical Perspectives
 on African Arts*. Washington DC: Smithsonian Institution Press.
1995 "Technology, Tradition and Lurex: The Art of Textiles in Africa"
 in *The Art of African Textiles: Technology, Tradition and Lurex*.
 London: Barbican Art Gallery. pp. 9-30.

Poyner, Robin
2001 "The Yoruba and the Fon." In Visona, Poyner, Cole and Harris (ed.).
 A History of Art in Africa. New York: Harry N. Abrams.

Preston, George
1981 Catalogue entry in Susan Vogel (ed.) *For Spirits and Kings:*
 African Art from the Paul and Ruth Tishman Collection.
 New York: The Metropolitan Museum of Art, p. 81

Puccinelli, Lydia
2000 *The Artistry of African Currency.*
 Washington D.C.: Smithsonian National Museum of African Art.

Quarcoopome, Nii Otokunor
1993 "Agbaa: Dangme Art and the Politics of Secrecy" in Mary Nooter, ed.
 Secrecy: African Art that Conceals and Reveals. New York: The
 Museum for African Art.
1997 "Art of the Akan." *The Art Institute of Chicago Museum Studies:*
 African Art at the Art Institute of Chicago 23:2 pp.135-147

Ranger, Terence O.
1989 "Missionary, Migrants and the Manyika: The Invention of Ethnicity in
 Zimbabwe." in LeRoy Vail (ed.) *The Creation of Tribalism in Southern*
 Africa. Los Angeles: Univerrsity of California Press. pp. 118-150.

Rattray, Robert Sutherland
1916 *Ashanti Proverbs.* Oxford: Clarendon Press.
1969 [1927] *Religion and Art in Ashanti.* Oxford: Clarendon Press.

Ravenhill, Philip L.
1994a "Bush Spirit Figures" in Doran H. Ross (ed.) *Visions of Africa: The*
 Jerome L. Joss Collection of African Art at UCLA, Los Angeles: Fowler
 Museum of Cultural History, University of California, Los Angeles.
1994b *The Self and Other: Personhood and Images among the Baule,*
 Côte d'Ivoire. Los Angeles: Fowler Museum of Cultural History,
 University of California, Los Angeles.

Reusch, Dieter
1998 "Imbiza kayibil' ingenambheki: the social life of pots," in Brendan
 Bell and Ian Calder (eds) *Umbunda: Aspects of Indigenous Ceramics*
 in KwaZulu Natal. Pietermaritzburg: Tataham Art Gallery.

Roberts, Allen F.
1988 "Of Dogon Crooks and Thieves." *African Arts* 21 (4):70-75, 91.
1995 *Animals in African Art: From the Familiar to the Marvelous.*
 New York: The Museum for African Art.
1996 "The Ironies of System D." In *Recycled, Reseen: Folk Art from*
 the Global Scrap Heap, edited by C. Cerny and S. Seriff:
 Santa Fe: Abrams for the Museum of International Folk Art.
1998 "Islam and Islamic Art in Africa" Field Research Essay
 in Christopher Roy (ed.) *Art and Life in Africa, CD-ROM.*
 Iowa City: Art and Life in Africa Project, The University of Iowa.

Roberts, Allen F. and Mary Nooter Roberts
2003 *A Saint in the City: Sufi Arts of Urban Senegal.* Los Angeles: Fowler
 Museum of Cultural History, University of California, Los Angeles.

Rodrigues de Areia, Manuel L.
1985 *Les Symboles Divinatoires.* Coimbra, Portugal: Coimbra University

Ross, Doran
1995 Catalogue entry in Tom Phillips (ed.)
 Africa: The Art of a Continent. New York: Prestel, p. 438.

Ross, Doran (ed.)
1992 *Elephant: The Animal and Its Ivory in African Culture.*
 Los Angeles: Fowler Museum of Cultural History,
 University of California, Los Angeles.
1994 *Visions of Africa.* Los Angeles: Fowler Museum of Cultural History,
 University of California, Los Angeles.
1998 *Wrapped in Pride: Ghanaian Kente and African American Pride.*
 Los Angeles: Fowler Museum of Cultural History,
 University of California, Los Angeles.

Roy, Christopher D.
1992 *Art and Life in Africa.* Iowa City: The University of Iowa Museum of Art.

Rubin, Arnold
1988 *Marks of Civilization.*
 Los Angeles: Museum of Cultural History, University of California.

Sarpong, Peter
1971 *The Sacred Stools of the Akan.*
 Lema, Ghana: Ghana Publishing Corporation.

Sieber, Roy
1972 "Kwahu Terracottas: Oral Traditions and Ghanaian History."
 in Douglas Fraser and Herbert Cole (eds.) *African Art and Leadership.*
 Madison: University of Wisconsin Press, pp. 172-83.
1986 "A Note on History and Style." in Ernie Wolfe, *Vigango.*
 Commemorative Sculpture of the Mijikenda of Kenya. pp.25-33.
1994 "African Furniture between Tradition and Colonization,"
 in Sandro Bocola (ed.) *African Seats.* New York: Prestel. pp. 31-37

Sieber, Roy and Roslyn Adele Walker
1987 *African Art in the Cycle of Life.*
 Washington D.C.: Smithsonian Institution Press.

Silverman, Raymond A.
1999 *Ethiopia. Traditions of Creativity.*
 East Lansing: Michigan State University Museum.

Siroto, Leon
1968 "Face of the Bwiiti." *African Arts* 1(3) 22-27, 86-89, 96.

Spencer, Anne
1982 *In Praise of Heroes: Contemporary African Commemorative Cloth.*
 Newark: The Newark Museum.

Stepan, Peter
2001 *World Art: Africa.* New York: Prestel Verlag.

Swiderski, Stanislaw
1989 *La Religion Bouti.* Vol. IV. New York: Legas.

Thompson, Robert Farris
1969 "Abatan: A Master Potter of the Egbado Yoruba."
 in Daniel Biebuyck (ed.) *Tradition and Creativity in Tribal Art.*
 Los Angeles: University of California Press. pp. 120—182.

Thompson, Robert Farris and Joseph Cornet
1981 *The Four Moments of the Sun.*
 Washington D.C.: National Gallery of Art.

Trowell, Margaret and K. P. Wachsmann
1953 *Tribal Crafts of Uganda.* London: Oxford University Press.

Vogel, Susan
1980 *Beauty in the Eyes of the Baule: Aesthetics and Cultural Values.*
 Philadelphia: Institute for the Study of Human Issues.

Turner, Victor
1969 *The Ritual Process.* Chicago: Aldine.

Westerdijk, Peter
1984 *African Metal Implements: Weapons, Tools and Regalia.*
 Collection of Fredrick and Claire Mebel.
 Greenvale: Hillwood Art Gallery, Long Island University.

Westerlund, David
1985 *African Religion in African Scholarship: A Preliminary Study of the*
 Religious and Political Background. Stockholm: Almqvist & Wiksell.

Weston, Bonnie E.
1984 "Northwestern Region, " in Herbert M Cole and Chike C. Aniakor
 (eds.) *Igbo Arts: Community and Cosmos.* Los Angeles: Museum of
 Cultural History, University of California, Los Angeles. pp. 145- 161.

Williams, Sylvia H. and Bryna M. Freyer
1999 "Kongo Hat" in *Selected Works from the Collection of the National*
 Museum of African Art. Washington D.C.:
 Smithsonian National Museum of African Art. p. 114.

Wolfe III, Ernie
1986 *Vigango Commemorative Sculpture of the Mijikenda of Kenya.*
 Williamstown: Williams College Museum of Art..

Womersley, Harold
1984 *Legends and History of the Luba.* Los Angeles: Crossroads Press.

Yoshida, Kenji
1995 "Lozi Bowl," in Tom Phillips (ed.)
 Africa. The Art of a Continent. New York: Prestel pp. 167-8.
2000 "Lidded Bowl," in John Mack (.ed.)
 Africa: Arts and Culture. New York: Oxford University Press. p. 178.

Zahan, Dominique
1960 *Sociétés d'Initiation Bambara.* Paris: Mouton.

Exhibition Checklist

*Asterisks denote catalogue illustrations
(See illustration captions for object details.)*

Leadership and Status

*Commemorative Head of a Queen Mother
(Iyoba)*
Benin kingdom, Edo peoples, Nigeria,
probably 18th century
The Field Museum, Chicago

Idiophone of an Ibis
Benin kingdom, Edo peoples, Nigeria,
probably 18th century
The Field Museum, Chicago

Wrapper (Kente)
Asante peoples, Ghana,
20th century
National Museum of African Art,
National Museum of Natural History,
Smithsonian Institution

Chair (Akonkromfi)
Asante Akan People, Ghana,
probably mid/late 19th century
The Art Institute of Chicago

Goldweights
Akan People, Ghana or Côte d'Ivoire
(Ivory Coast),
Eighteenth/ early twentieth century
The Art Institute of Chicago

Container for gold dust (Adakawa)
Akan People, Ghana, manufactured in England,
mid 19th century/ mid 20th century
Copper Alloy
H x Dia.: 8.9 x 2.9 cm (3 1/2 x 1 1/8 in.);
Chain length: 15 cm (5 7/8 in.)
The Art Institute of Chicago
Gift of the Britt Family Collection
1978.881

Equipment for weighing gold dust
Akan peoples, Ghana or Côte d'Ivoire
(Ivory Coast),
18th–late 19th century
National Museum of African Art,
Smithsonian Institution

Beaded stool
Bamileke peoples, Cameroon,
early 20th century
The Field Museum, Chicago

Stool
Kwere peoples, Bagamoyo district, Tanzania,
early 20th century
Wood
H x W x D: 37.3 x 40.8 x 40.8 cm
(14 11/16 x 16 1/16 x 16 1/16 in.)
National Museum of African Art,
Smithsonian Institution
Museum Purchase
94-10-1

Royal spear
Luba peoples, Democratic Republic of the Congo
(formerly Zaire),
early 20th century
The Field Museum, Chicago

Display axe
Songye, Ben Ekie people, Nsapo chiefdom,
Democratic Republic of the Congo
(formerly Zaire),
late 19th–early 20th century
Iron, wood, copper
H: 38 cm (15 in.)
National Museum of Natural History,
Smithsonian Institution
Gift of Herbert and Sarita S, Ward
322669

Hat (Botolo)
Ekonda, Democratic Republic of the Congo
(formerly Zaire),
early 20th century
National Museum of African Art,
Smithsonian Institution

Ceremonial Blade
Ekonda, Democratic Republic of the Congo
(formerly Zaire),
early 20th century
National Museum of African Art,
Smithsonian Institution

Man's Robe (Riga)
Hausa people, Nigeria,
20th Century

Door for Palace Interior (Ilekun Afin), 1930-1950
Oshamuko of Osi, Yoruba people,
Ekiti area, Nigeria
Indianapolis Museum of Art

Beaded Crown with Veil (Adenla)
Yoruba peoples, Nigeria,
20th century
UCLA Fowler Museum of Cultural History

Crown for devotee of Obatala Ogiyan
José Rodríguez (1956 -)
United States of America,
1997
UCLA Fowler Museum of Cultural History

Death and the Ancestors

Funeral Shroud (Lamba arindrano)
Betsileo peoples, Madagascar,
early 20th century
Raw silk, beads
H x W x D: 220 x 140 cm (86 5/8 x 55 1/8 in.)
The Field Museum, Chicago
184140

*Mourning Body Wrapper Textile
(Adinkra kobene)*
Akan peoples, Asante group, Ghana,
20th century
New Orleans Museum of Art

*Reliquary figure with tied bundle
(Nbumba bwiti)*
Kota-Ondoumbo or Sango peoples, Gabon,
19th–early 20th century
New Orleans Museum of Art

Standing male figure (Singiti)
Hemba peoples, Democratic Republic of Congo
(formerly Zaire),
early 20th century
Wood
H x W x D: 43.7 x 14 x 14 cm
(17 3/16 x 5 1/2 x 5 1/2 in.)
New Orleans Museum of Art
Bequest of Victor K. Kiam
77.167

Royal Male Memorial Head
Akan peoples, Asante group, Ghana,
19th–early 20th century
New Orleans Museum of Art

Twin figures (Ere ibeji)
Yoruba peoples, Nigeria,
20th century
UCLA Fowler Museum of Cultural History

Pair of Figures (Tadep)
Mambila peoples, Cameroon,
20th century
H: 30.5 and 29.2 cm (12 and 11.5 in.)
Collection of Charles and Kent Davis

Commemorative Posts (Vigango)
Giriama and Chonyi Peoples,
Mijikenda Complex, Kenya
Indianapolis Museum of Art

Face Mask with female figure (Satimbe)
Dogon people, Mali,
early 20th century
New Orleans Museum of Art

Mask, (Kponyungo)
Senufo People, Côte d'Ivoire (Ivory Coast),
mid 19th century/ mid 20th century
The Art Institute of Chicago

Elephant mask (Mbap nteng)
Bamileke peoples, Cameroon,
20th century
The Field Museum, Chicago

Beer Container (Ukhana)
(probably Zulu) peoples, Northern Nguni,
1940/1950
The Art Institute of Chicago,

Headrest (Mutsago)
Shona, Zimbabwe,
late 19th–early 20th century
Private collection

Snuff container (Nhekwe)
Shona, Zimbabwe,
late 19th–early 20th century
Private collection

Utility and the Art of Living

Mat
Swahili peoples, Tanzania,
late 19th–early 20th century
The Field Museum, Chicago

Hat (Kofia ya dirizi)
Swahili peoples, Tanzania,
late 20th century
Cotton
H x W x D: 11.2 x 17.4 x 16.9 cm
(4 7/16 x 6 7/8 x 6 5/8 in.)
National Museum of African Art,
Smithsonian Institution
Gift of Mrs. E. W. Tompkins
80-5-1

Hat (Mpu)
Kongo peoples, Mayombe region, Democratic
Republic of the Congo (formerly Zaire),
early 20th century
National Museum of African Art,
Smithsonian Institution

*Baby bonnet (Dambalam)
Bura peoples, Nigeria,
late 20th century
National Museum of African Art,
Smithsonian Institution

Combs
Yao peoples, Tanzania,
late 20th century
Reed, plant fiber, bead
H x W x D: 11.5 x 9.5 x 0.6 cm
(4 1/2 x 3 3/4 x 1/4 in.)
H x W x D: 8.9 x 5.6 x 0.5 cm
(3 1/2 x 2 3/16 x 3/16 in.)
National Museum of African Art,
Smithsonian Institution
Acquisition grant from the
James Smithson Society

Comb
Baule peoples, Côte d'Ivoire (Ivory Coast),
early-mid 20th century
Wood
H x W x D: 17.0 x 8.8 x 1.4 cm
(6 11/16 x 3 7/16 x 9/16 in.)
National Museum of African Art,
Smithsonian Institution
Gift of Uzi Zucker
81-27-10

Hair combs
Democratic Republic of Congo (formerly Zaire),
early 20th century
Wood
H (largest): 18.4 cm (7 1/4 in.)
The Art Institute of Chicago
Worcester Children's Fund
1924.22-4, 1924.22.26 and 1924.22.27

*Headrest, (Musawa or musua)
Yaka People, Democratic Republic of Congo
(formerly Zaire),
mid 19th century/early 20th century
The Art Institute of Chicago

Backrest
Mongo people, Democratic Republic of the
Congo (formerly Zaire), early 20th century
Wood
National Museum of Natural History,
Smithsonian Institution
Purchased from Dorsey Mohun
174760

Sword and leather sheath
Vai and Manding people, Liberia,
late 19th century
Iron, leather, brass
H: 78 cm (30 3/4 in.)
National Museum of Natural History,
Smithsonian Institution
Collected by W. P. Tisdel, 1885
E76258

Arm dagger and scabbard (Gozma)
Tuareg peoples,
regions of West and North Africa,
early-mid 20th century
Dagger: Iron, silver, copper alloy,
synthetic resin, plastic
Scabbard: Leather, silver
Dagger H x W x D: 51.1 x 11.1 x 2.1 cm
(20 5/16 x 4 3/8 x 13/16 in.)
Scabbard H x W x D: 36.8 x 10.9 x 10.2 cm
(14 1/2 x 4 5/16 x 4 in.)
National Museum of African Art,
Smithsonian Institution
Museum Purchase and gift of Mrs. Florence
Selden in memory of Carl Selden
93-6-4.1 and 93-6-4.2

Neck ring
Fang peoples, Cameroon,
late 19th–early 20th century
Copper alloy
H x W x D: 7 x 19.4 x 16.5 cm
(2 3/4 x 7 5/8 x 6 1/2 in.)
National Museum of African Art,
Smithsonian Institution
Gift from the Collection of Jacob A. Reis, DD,
and Eleanor N. Reis RN
84-19-3

Spear blade currency (Liganda)
Lokele peoples, Lomami-Lualaba River region,
Democratic Republic of the Congo
(formerly Zaire),
19th century
Iron
H x W: 177.8 x 39.7 cm (70 x 15 5/8 in.)
National Museum of African Art,
Smithsonian Institution
Museum Purchase
83-3-14

*Currency tokens (Mezong)
Kwele peoples, Gabon and
Republic of the Congo,
19th or early 20th century
Private collection

Basket
Teke people, Democratic Republic of the Congo
(formerly Zaire),
late 19th century
Palm fibers
National Museum of Natural History,
Smithsonian Institution
Collected by Heli Chatelain, 1893
E166203

*Basket (Agaseki or Ibeseke)
Tutsi people, Rwanda,
20th century
National Museum of Natural History,
Smithsonian Institution

Cup
Kuba peoples, Democratic Republic of Congo
(formerly Zaire),
mid 19th century/mid 20th century
Wood
H: 14 cm (5 1/2 in.)
The Art Institute of Chicago
Gift of Mr. Raymond Wielgus
1957.106

Spoon
Effutu peoples, Ghana,
early 20th century
Wood
H x W x D: 26.1 x 8.0 x 7.1 cm
(10 1/4 x 3 1/8 x 2 13/16 in.)
National Museum of African Art,
Smithsonian Institution
Gift of Evelyn A. J. Hall and John A. Friede
86-9-1

*Food Bowl (Mukeke)
Lozi people, Zambia,
20th century
UCLA Fowler Museum of Cultural History

*Container
Northern Nguni peoples, South Africa,
probably late 19th century
The Art Institute of Chicago

*Pot for Eyinle (Erinle) riverine deity
(Awo Ota Eyinle)
Abatan Odefunke Ayinke Ija of Oke-Odan
Yoruba, Egbado people, Nigeria,
early 20th century
National Museum of Natural History,
Smithsonian Institution

*"Amphora II"
Magdalene Odundo, Kenya, 1997
Indianapolis Museum of Art

Transitions and Dealing with Adversity

Staff for Champion Farmer (Tefalipitya)
Senufo people, Cote d'Ivoire (Ivory Coast),
20th century
Wood, iron, fiber, cloth, mastic
H x W x D: 76.2 x 7.6 x 7 cm (30 x 3 x 2 3/4 in.)
Indianapolis Museum of Art
Gift of Mr. and Mrs. Harrison Eiteljorg
IMA1989.186

*Puppet/mask (Sigi)
Yaya Coulibaly (1959 -)
1987
Bamana peoples, Mali
Collection of Craig A. Subler

*Mask (Kholuka)
Yaka people, Democratic Republic of the Congo
(formerly Zaire),
20th century
UCLA Fowler Museum of Cultural History

Mask (Sowei)
Mende peoples, Sierra Leone,
20th century date
Wood, fiber
H: 38.7 cm (15 1/4 in.)
UCLA Fowler Museum of Cultural History
Gift of the Wellcome Trust
FMCH X65.4779

*Mask (Chikunza)
Chokwe peoples, Angola/ Zambia,
20th century
Private collection

*Maiden Spirit Mask (Agbogho mmuo)
Igbo peoples, Nigeria,
early/mid 20th century
The Art Institute of Chicago

*Masker Garment
Igbo peoples, Nigeria,
20th century
Indianapolis Museum of Art

*Elephant Mask (Ogbodo enyi)
Igbo peoples, Nigeria,
20th century
UCLA Fowler Museum of Cultural History

Mask (Idangani)
Salampasu, Democratic Republic of the Congo
(formerly Zaire),
20th century
Fibers, pigment
H x W x D: 83 x 23 x 24 cm
(36 3/4 x 9 x 9 1/2 in.)
Private collection

*Divination Basket and rattle (Ngombo ya cisuka)
Chokwe peoples, Angola/ Zambia,
19th or early 20th century
Private collection

Diviner's Board (Opon Ifa)
Areogun of Osi-Ilorin c. 1880-1954,
Yoruba, Nigeria,
early/mid 20th century
The Art Institute of Chicago

Diviner's Storage Container (Opon Igede)
Areogun of Osi-Ilorin c. 1880-1954,
Yoruba, Nigeria,
probably early 20th century
Wood
H x Dia.: 49.5 x 52 cm (19 1/2 x 20 1/2 in.)
The Art Institute of Chicago
Restricted gift of Marshall Field
1999.288

Male figure (Bateba)
Lobi people, Burkina Faso,
20th century
Indianapolis Museum of Art

Figure (Nkisi)
Kongo peoples, Democratic Republic of the
Congo (formerly Zaire),
20th century
New Orleans Museum of Art

Connecting with the World

Plaque depicting two Portuguese
Benin kingdom, Edo peoples,
Nigeria, 16th – 17th century
The Field Museum, Chicago

Crucifix (Nkangi Kidutu)
Kongo peoples, Democratic Republic
of the Congo (formerly Zaire),
late 17th – early 18th century
National Museum of African Art,
Smithsonian Institution

Unbelievable
Godfried Donker, Ghana,
1994
Mixed media on paper
H x W x D: 62.7 x 47.7 cm
(24 11/16 x 18 3/4 in.)
National Museum of African Art,
Smithsonian Institution
Purchased with funds provided by the
Smithsonian Collections Acquisition Program
96-21-3

Battle of Adwa
Ethiopia,
1930
National Museum of Natural History,
Smithsonian Institution

Shield
Amhara peoples, Ethiopia,
early 19th–early 20th century
Leather, silver alloy, thread, cloth
H x W x D: 49.5 x 49.5 x 16.4 cm
(19 1/2x 19 1/2 x 6 7/16 in.)
National Museum of African Art,
Smithsonian Institution
Gift of Denyse and Marc Ginzberg
98-21-1

Prayer stick finial
Ethiopian Orthodox, Ethiopia,
17th century
Copper alloy
H x W x D: 15.6 x 9.7 x 2.5 cm
(6 1/8 x 3 13/16 x 1 in.)
National Museum of African Art,
Smithsonian Institution
Museum Purchase
97-19-4

Processional cross
Abyssinian Christian peoples, Ethiopia,
15th–19th? century
Brass
H x W x D: 30.5 x 12.7 x .6 cm (12 x 5 x 1/4 in.)
New Orleans Museum of Art
Gift of Ambassador Franklin H. Williams
86.382.1

*Commemorative Roller Print of Basilique Notre
Dame de la Paix, Yamoussoukro, Côte d'Ivoire*
Printed at Utexi, Côte d'Ivoire (Ivory Coast),
1990
Industrial roller print on cotton
H x W: 114 x 175 cm (45 x 69 in.)
Collection of Kathleen Bickford Berzock

*Commemorative Roller Print of Basilique Notre
Dame de la Paix, Yamoussoukro, Côte d'Ivoire*
Designed and printed at Utexi, Côte d'Ivoire
(Ivory Coast),
1990
Industrial wax print on cotton
Collection of Kathleen Bickford Berzock

Commemorative Java Print of Pope John Paul II
Printed at Vlisco, Helmond, Holland,
1990
Industrial Java print on cotton
Collection of Kathleen Bickford Berzock

*Commemorative Print at death of Tanzanian
President Julius Nyerere*
Printed at Mali Ya KTM, Tanzania,
1999
Industrial print on cotton
Private Collection

Printed Textile (Khanga)
Printed by Nisan Exports, Mumbai,
India for Mali Ya Chavda, Zanzibar
Swahili saying "Usinionee Uchungu Riziki Kanipa
Mungu" meaning "Don't See Me As Suffering,
God Gives Me Provision."
Industrial print on cotton
Private Collection

Al-Buraq, 1996
Mor Gueye
Senegal
Collection of Craig Subler

Bus to Touba, 1996
Azoubade
Senegal
Private collection

Amadou Bamba, 1990
Mor Gueye
Senegal
Private collection

Bush Spirit Figures (Asie Usu)
Baule, Côte d'Ivoire, 20th century
UCLA Fowler Museum of Cultural History

Other World Figures (blolo bian, blolo bla)
Baule, Côte d'Ivoire, male c. 1960, female c.
1965
UCLA Fowler Museum of Cultural History

Mamba Muntu (Mami Wata),1988
Democratic Republic of the Congo
(formerly Zaire),
1988
Oil paint on flour-sack
H x W x D: 36 x 66 x 2 cm
(14 3/16 x 26 x 3/4 in.)
Private collection

Animal, 1972
Jimoh Buraimoh (1943 -)
Yoruba peoples, Nigeria
The Field Museum, Chicago

*Ceremonial Hat Masqueraders
(Lagos-Renown Eyo Masqueraders)*
1996
Twins Seven Seven (1944 -), Nigeria,
Indianapolis Museum of Art

The Dying Beast, 1993
Ezrom Legae (1937–1999), South Africa
The Indianapolis Museum of Art

Assassins, 1996
Ezrom Legae (1937–1999), South Africa
Indianapolis Museum of Art

*Cold Turkey: Stories of Truth and Reconciliation
(De Kock ready to sing) and (Poison Victim),*
1996
Sue Williamson (1941 -), South Africa
Acetate, steel, plexiglass, frame
H x W x D of each 63.5 x 89.8 x 10 cm
(25 x 35 3/8 x 3 15/16 in.)
National Museum of African Art,
Smithsonian Institution
97–21-1.1 and 97–21-1.2

The University of Tennessee does not discriminate on the basis of race, sex, color, religion, national origin, age, disability, or veteran status in provision of education programs and services or employment opportunities and benefits. This policy extends to both employment by and admission to the University. The University does not discriminate on the basis of race, sex, or disability in the education programs and activities pursuant to the requirements of Title VI of the Civil Rights Act of 1964, Title IX of the Education Amendments of 1972, Section 504 of the Rehabilitation Act of 1973, and the Americans with Disabilities Act (ADA) of 1990. Inquiries and charges of violation concerning Title VI, Title IX, Section 504, ADA, the Age Discrimination in Employment Act (ADEA), or any of the other above referenced policies should be directed to the Office of Equity and Diversity, 1840 Melrose Avenue, Knoxville TN 37996-3560; telephone (865) 974-2498 (TTY available). Requests for accommodation of a disability should be directed to the ADA Coordinator at the Office of Human Resources Management, 600 Henley Street, Knoxville TN 37996-4125.

Publication authorization number E01-1006-003-03 Design and production assistance provided by Creative Services, Public Relations, The University of Tennessee (job # 6336)